# Art in Nature

## The Clark Inside and Out

# Art in Nature

## The Clark Inside and Out

Text by Timothy Cahill

Sterling and Francine Clark Art Institute
Williamstown, Massachusetts

Distributed by Yale University Press
New Haven and London

Produced by the Publications Department of the Sterling and Francine
Clark Art Institute, 225 South Street, Williamstown, MA 01267

Curtis R. Scott, Director of Publications
David Edge, Graphic Design and Production Manager
Katherine Pasco, Production Editor

Distributed by Yale University Press, P.O. Box 209040,
302 Temple Street, New Haven, CT 06520-9040
www.yalebooks.com

Composed in Trade Gothic Light and Swift Light
Printed by Springfield Printing, North Springfield, Vermont

Printed and bound in the United States of America
10 9 8 7 6 5 4 3 2 1

Library of Congress Cataloging-in-Publication Data
Sterling and Francine Clark Art Institute.
    Art in nature : the Clark inside and out / text by Timothy Cahill.
        p. cm.
    ISBN 0-300-11107-X (alk. paper)—ISBN 0-931102-63-4 (pbk. : alk. paper)
    1. Sterling and Francine Clark Art Institute—History. 2. Art—
Massachusetts—Williamstown. I. Cahill, Timothy, 1958– II. Title.
N867.A828 2005
708.144'1—dc22
                                            2005042647

Photography Credits

Unless otherwise stated in the captions, all works of art are from the collection
of the Sterling and Francine Clark Art Institute (photos by Michael Agee): 2–3,
16 bottom, 17 top, 37–39, 40 bottom, 41, 50–52, 53 middle and bottom,
56–57 top, 56 bottom, 58 right, 59 top and middle, 60–64, 65 top and
middle, 68–73, 78–81, 82 top, 83–85, 92, 93 bottom, 108 top, 115 middle
and bottom, 123 bottom

Michael Agee: cover, 8–9, 12 bottom, 13 bottom, 20–23, 24 right, 28 top,
45 bottom, 76–77, 86–89, 104–5, 106 bottom, 107, 109 top, 126–27; Merry
Armata: 19 middle right, 26, 82 bottom; David Edge: 14, 28 bottom, 91 top,
97 left, 98–99, 109 bottom; Arthur Evans: 4–5, 10–11, 13 top right, 16 top,
27 left, 58 left, 74–75, 90 middle and bottom, 91 middle and bottom, 96,
100–101, 106 top, 112, 114, 116 top and bottom right, 117, 120 top and
right, 121 top, 122–23 top, 128; Blake Gardner: 94 bottom, 108 bottom, 116
bottom left, 120 bottom left; Kevin Kennefick: 19 bottom left, 57 bottom, 95 right,
124–25; Mark McCarty: 12–13 top, 17 bottom, 19 bottom right, 48–49, 53
top, 58 left, 59 bottom, 65 bottom, 93 top and upper right, 94–95 top, 97 top
right and bottom, 106 middle, 113 top, 115 top, 118–19; www.MetroHistory.com:
42; Kris Qua: 15, 19 top, 24 left middle and bottom, 32–33, 46–47, 54–55,
57 top right, 66–67, 102–3, 113 bottom, 121 bottom; Julia Sabot: 27 left;
Anthony Salamone: 18; Sterling and Francine Clark Art Institute Archives:
34 bottom, 35, 36, 40 top, 43, 44 top, 45 top, 90 top; Nicholas Whitman
(nwphoto.com): 24–25 top, 27 right, 29–31, 34 top left, 110–11, 122
bottom; Williams College Archives and Special Collections: 44 bottom

COVER  Water lilies grace the surface of a pond alongside the Clark
PAGES 2–3  Detail of *Spring in Giverny,* 1890, by Claude Monet
PAGES 4–5  View of "The Hopper" in winter, approaching Williamstown
from the south
PAGES 8–9  East facade of the Clark in summer
PAGES 10–11  *The Three Graces,* 1872, by Jean-Baptiste Carpeaux

# Contents

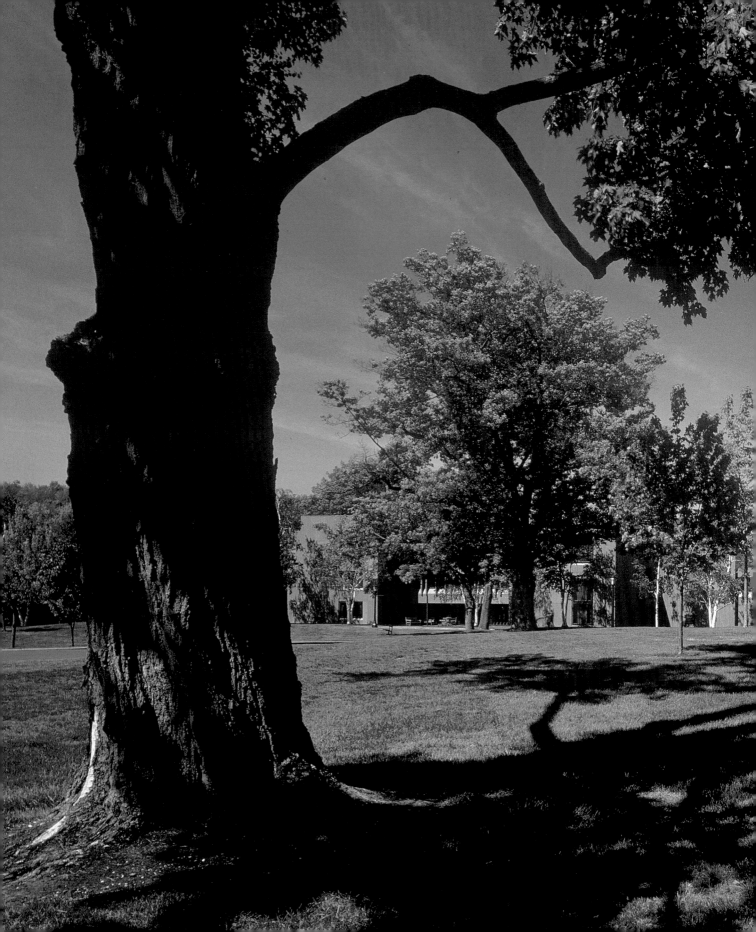

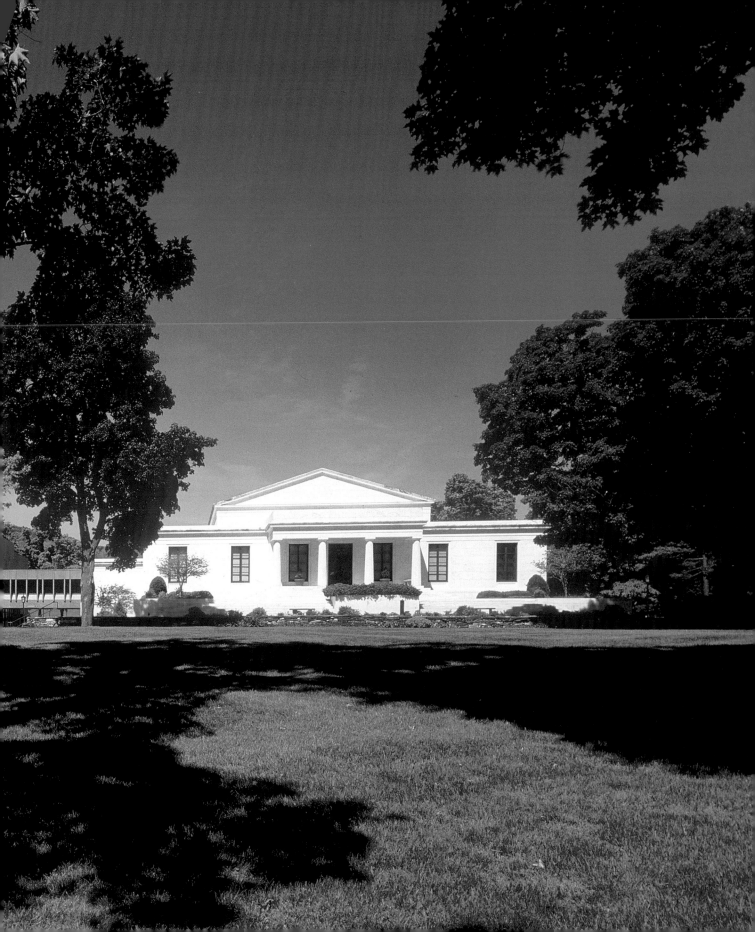

Visitors to the Sterling and Francine Clark Art Institute have long recognized that the quality of the Clark's collections and exhibitions, the importance of its Research and Academic Program, and the beauty of its intimate galleries and natural surroundings make it distinct among American art museums. In this multilayered portrait of the Clark, Timothy Cahill highlights some of the Clark's many masterpieces, but readers will be reminded in words and pictures that there is much more to the Clark experience. From the organization of international exhibitions, to the staging of fun-filled family days and community band concerts, to the presentation of scholarly lectures and symposia, the Clark's active public and academic program fosters a deeper under-standing of art and culture for people of all ages and backgrounds. Enhancing the impact of the Clark's programming is its spectacular setting on 140 vista-filled acres in a rural New England college community. Whether you are a longtime friend of the Clark or a new visitor, I'm sure that this book will encourage you to visit or revisit the Clark, make new discoveries, and find a "museum of your own."

Michael Conforti, Director

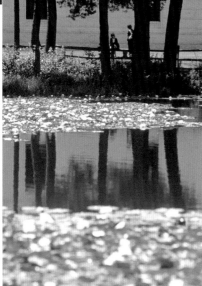

## First Impressions

My first visit to the Sterling and Francine Clark Art Institute was in 1980, exactly halfway into the museum's fifty-year history. Even then, the Clark's reputation as a premier collection of European art was already immutable. I'd been in the Berkshires only a few months, and in that short time had heard rave upon rave about the place. I went to see for myself.

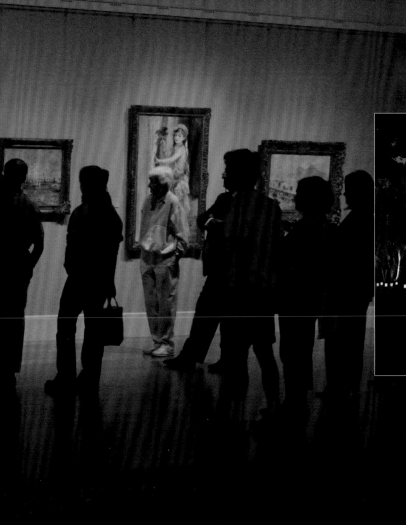

LEFT  The Clark's central Impressionist gallery features some of the most beloved works in the collection
ABOVE  Festive paper lanterns light the path to the entrance of the museum during an evening celebration
OPPOSITE  The reflection of the marble building shimmers on the surface of the lily pond, while visitors linger outside to enjoy the scenery
BELOW  A heavy snowfall blankets the front steps of the original "temple of art"

The institution I arrived at that first day was, in many ways, much the same as the Clark today. The museum's first quarter century had been one of significant growth. The Institute opened in 1955, a Greek-revival temple of white marble built by Sterling and Francine Clark to display the dazzling collection of paintings, drawings, prints, silver, and porcelain they had acquired over four decades. In the 1960s, an ambitious academic initiative had brought numerous distinguished scholars to advise and expand the Clark, and to carry the word through the art world of its exceptional resources. In 1973, a plum-gray granite building was added to house the Institute's burgeoning art history library and support a new master's program in art history, cosponsored with Williams College.

The Clark had been founded on a collection of superb paintings by the likes of Piero della Francesca and Perugino, Gainsborough and Goya, Sargent and Homer, and a lineage of French savants from Géricault and Corot through Millet, Daumier, Manet, Monet, Pissarro, Degas, Renoir, and Toulouse-Lautrec. The Clarks owned watercolors by Turner, Whistler, and Homer; master drawings by Dürer and Rembrandt and Rubens; sculpture by Remington and Rodin; and one of the finest collections of English and Irish silver this side of Windsor Castle. The collection had been assembled in near-complete privacy and, when it finally went public, left the art world agog. *Life* magazine ran a two-page color photo of the Clark's best paintings, and the inventory of masterpieces looked like it could have come from the vaults of the Louvre or the Metropolitan Museum of Art. This was the stuff of world capitals and grand tours, nestled in a remote valley of rural Massachusetts. It all seemed so *unlikely*. Further, by the time I arrived, the collection had been augmented by three superb additions—an early Renaissance altarpiece by Ugolino di Nerio, a virtuoso rococo portrait by Jean-Honoré Fragonard, and a view of the Rouen cathedral by Claude Monet. These pictures added considerably to the Institute's growing status as one of the country's preeminent small museums.

> But on that brilliant September day of my first visit, my first impression wasn't of art at all, but of the slender, graceful birches that front the granite building. ...Even before setting foot in the galleries, I was aware of the presence of a kind of perfection.

But on that brilliant September day of my first visit (one of those afternoons of crystalline Berkshire sunshine), my first impression wasn't of art at all, but of the slender, graceful birches that front the granite building. Their paper-white trunks gleamed in the sun and rhymed with the sparkling marble of the museum temple nearby. Even before setting foot in the galleries, I was aware of the presence of a kind of perfection.

The Clark was my first direct experience with many of the painters presented there, and while I wish I could say I grasped the insight and depth of the Institute's best works, that came later. What struck me that first day

OPPOSITE William Bouguereau's *Nymphs and Satyr* of 1873 is for many visitors—young and old—one of the most memorable works in the collection

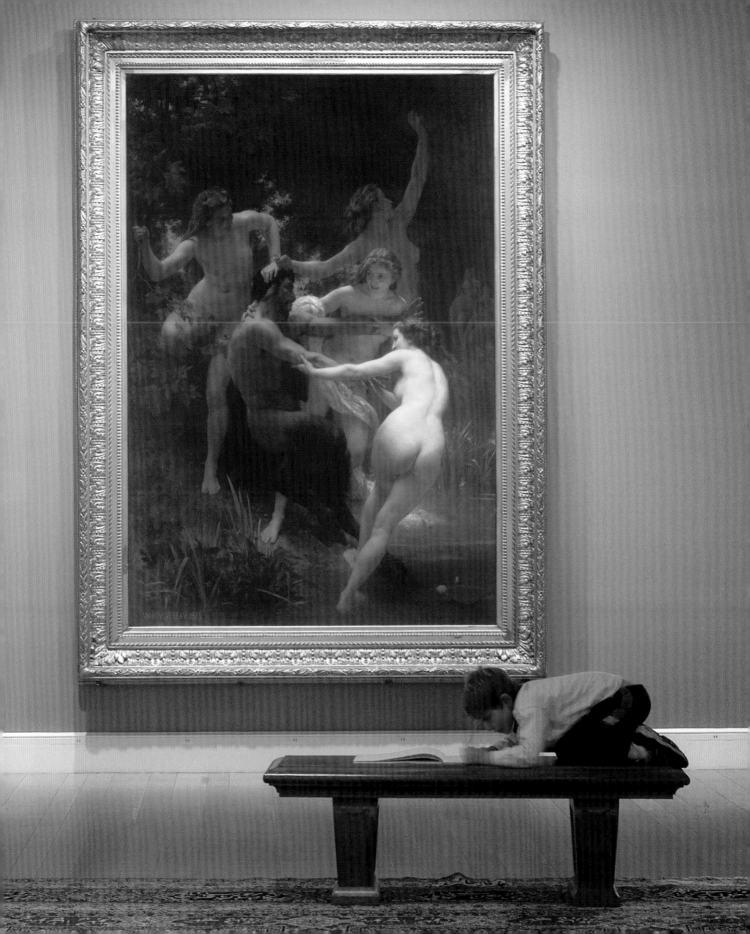

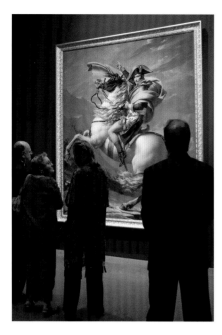

ABOVE The Clark's special exhibitions provide visitors with fresh perspectives on important works, such as Jacques-Louis David's monumental *Bonaparte Crossing the Alps at Grand-Saint-Bernard,* 1800–1801, from the Musée national des Châteaux de Malmaison et Bois-Préau
BELOW *Moss Roses in a Vase,* 1882, by Edouard Manet
OPPOSITE The Clark's extraordinary art history library, among the best in the country, is a rich resource for scholars and students alike
OPPOSITE INSET *The Warrior,* c. 1769, by Jean-Honoré Fragonard

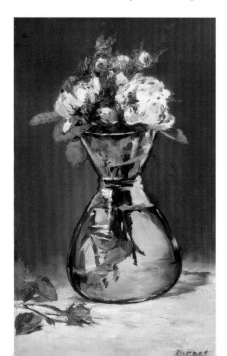

were the tense dramatics of Winslow Homer's high-surf rescue scene *Undertow* and the giddy eroticism of William Bouguereau's *Nymphs and Satyr* (which remains, a quarter century later, a favorite friend).

Nevertheless, I had been initiated into the unique experience of the Clark, its blend of art and nature. This experience is the essence of the Institute and has remained constant throughout its history. Over the course of fifty years, the Clark has grown into an impressive maturity. Few institutions of the Institute's modest size—it has just sixteen galleries for the permanent collection—express themselves with such intelligence and savvy. The collections have been continually upgraded with new acquisitions, ranging from works by Old Masters like the Napoleonic neoclassicist Jacques-Louis David and the Flemish Mannerist Joachim Wtewael, to those of such early modernists as Gauguin, Cézanne, Munch, and even Picasso. Holdings of works on paper have similarly expanded, and in the 1990s the museum added photography to its collection, amassing a fine cross section of nineteenth- and early-twentieth-century photographic works. Greatly enhanced facilities for temporary exhibitions helped make the museum a destination for important summer and winter shows. Loans from important American and European institutions, as well as private collections, have allowed the Clark in recent years to present seminal works by Courbet, Delacroix, Géricault, David, Millet, Manet, Sargent, Monet, Rossetti, Turner, and Klimt.

Special exhibitions do more than attract tourists (which they surely do; there are summer days when the galleries are as busy as any big-city museum)—they are also a dimension of what director Michael Conforti calls the Institute's "intellectual creativity." Even as they build popular interest in the visual arts, the Clark's special exhibits are designed to both advance scholarship and expand the public's understanding of art.

In the mid-1990s, the Clark entered a period of intellectual and physical growth that continues in the new century. The institution has become a leading center of advanced research and scholarly discussion. In addition to conferences, symposia, and workshops, the Clark Fellows program is one

of the profession's most coveted residencies for art historians, curators, critics, and theorists from the U.S. and abroad. While most of the intellectual activity takes place out of sight of the average Clark visitor, it is felt nonetheless, in the exhibits presented, the books published, the esteemed guests who visit the museum, and, intangibly but significantly, in the general atmosphere of dynamism throughout.

Moments of discovery and breakthrough are common at the Clark. At any given time, while a guide is conducting a gallery talk, a curator could be collaborating with a guest scholar, a graduate student may find the exact piece of knowledge to further his or her research, and a conversation between Clark Fellows might set in motion whole new directions of thought. Every day, at every level, the Institute is an engine and haven for intellectual activity. Ideas happen here.

The Clark, in truth, is an institution with two identities. As both an art museum and a center for research and higher education, it can have

The Clark's special exhibits are designed to both advance scholarship and expand the public's understanding of art.

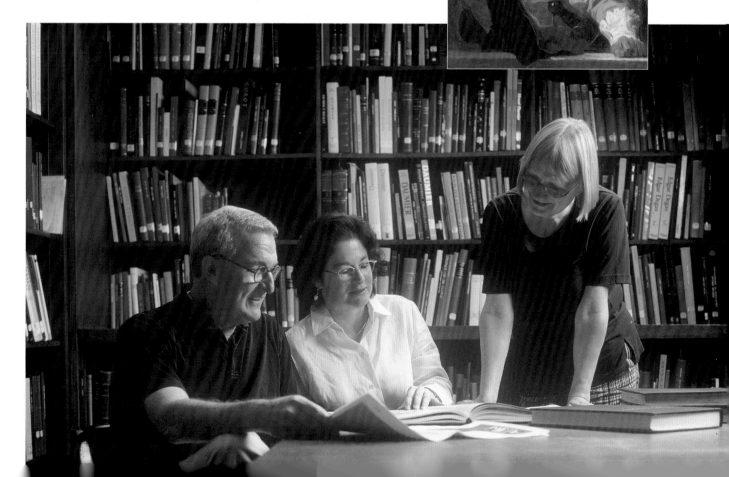

ABOVE Picnics are a time-honored
tradition at the Clark

things both ways. In its galleries, the museum presents six hundred years of Western art built upon classical ideals of beauty and order. Meanwhile, in research seminars and scholarly debates, the Western canon, and the aesthetic it's based on, is subjected to continual scrutiny, analysis, and revision. Museum-goers at the Clark enjoy the familiar pleasures of painterly storytelling, spectacle, and splendor, while intellectuals dissect these same pleasures, questioning assumptions and advancing new findings on the nature of visual

culture. The point of impact, where traditions meet the restless challenges of new theories, is the essence of the Clark's vitality.

But there is even more to the Clark experience, for all of this human activity takes place within the frame of the Institute's spectacular natural setting, a context far older and more enduring than theories or tastes. Other institutions may offer exceptional art and a vibrant intellectual atmosphere, but none deliver them surrounded by the Berkshires, those cradling green and blue hills of grandeur and inspiration. At the center of the Clark's 140-acre property are rolling lawns and stately trees for picnics, concerts, and strolls. Beyond lies a rural landscape where dairy cows graze and a pond mirrors the changing weather and seasons. Farther still are wooded hiking trails that climb to a high hill, and there, a vista ringed by the Berkshire range.

It's hard to capture fully the Clark's sublime convergence of nature and art. The connection occurs with such grace that on your first visit you instinctively comprehend how the two are intertwined. There is a quietness to the place. Great art and unspoiled nature impart the same knowledge, a push and pull of opposing forces, the dialectic of logic and feeling, cyclical rhythms of abundance and decline. The Berkshires' natural beauty is much more than an added bonus to the institution's collections and programs. It is, in ways tangible and intangible, an integral ingredient of the Sterling and Francine Clark Art Institute.

ABOVE AND BELOW The Clark's lawns, meadows, and woodlands invite visitors to explore the natural beauty of its 140-acre campus
FOLLOWING PAGES Water lilies grace the surface of a pond alongside the Clark

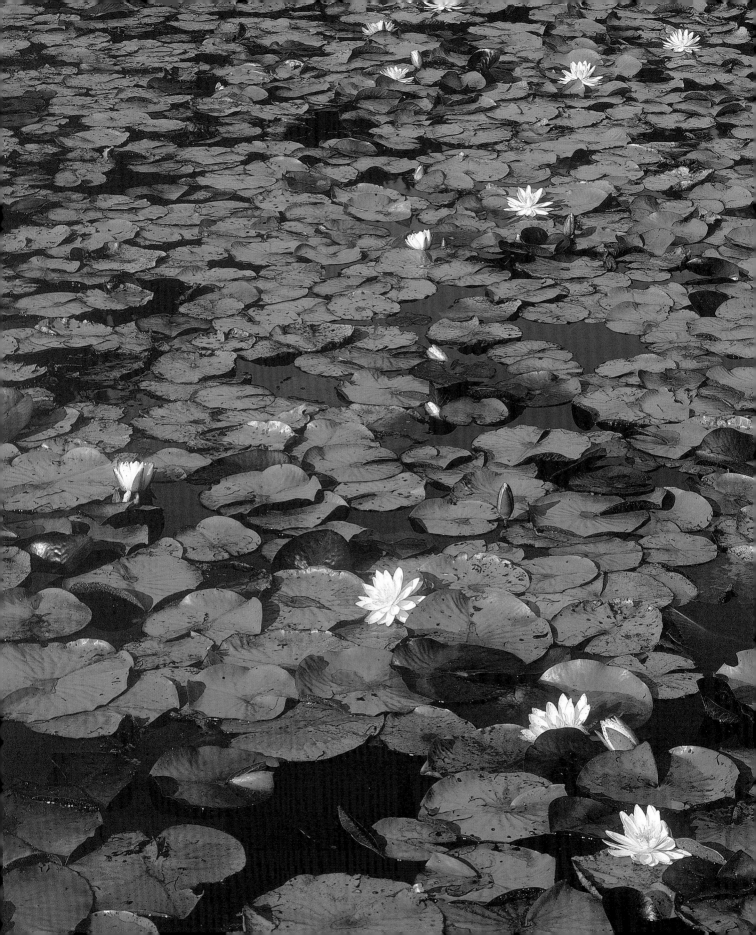

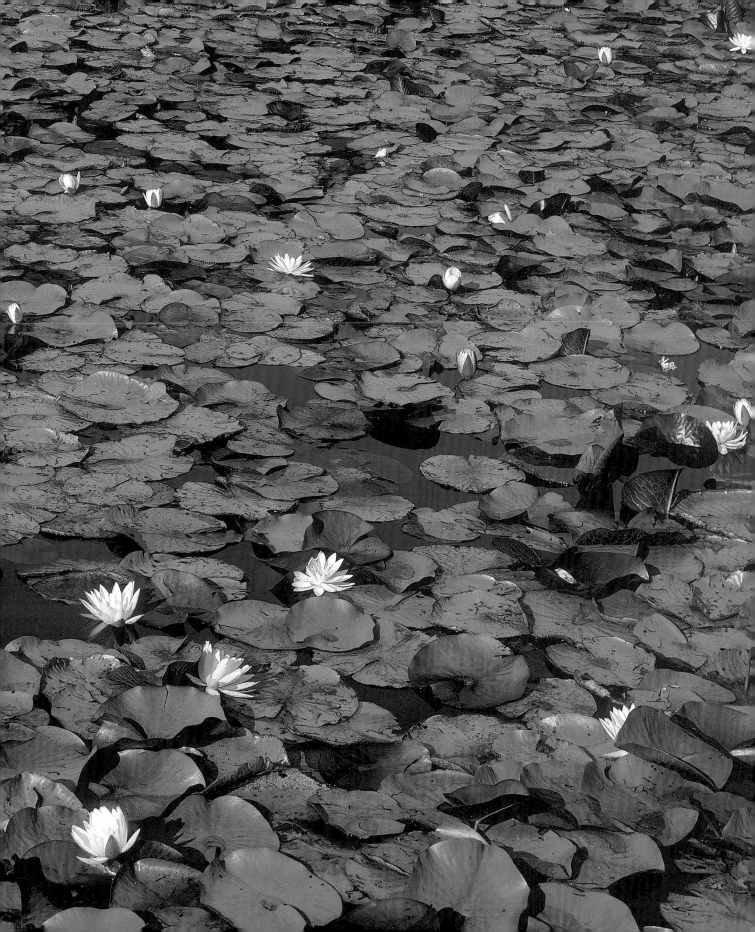

# The Setting

While the civilizations of Europe were creating many of the masterpieces on view in the Clark's collections, the Berkshires were still a wilderness of dense forests, rushing streams, and steep slopes. Two hundred fifty years ago, as settlers moved west from Boston and the Connecticut River valley, they carved out farms and small townships amid the same hills that to this day inspire visitors with their beauty.

ABOVE  In winter, Stone Hill is a popular
destination for skiing and sledding
PREVIOUS PAGES  View of the Clark from atop Stone Hill

The Clark sits at the foot of Stone Hill, one of Williamstown's main geological features. The hill's eastern face, an upland pasture now reverted largely to woods, dominates the museum's 140-acre campus of lawns, hiking trails, and scenic views. This promontory was formed 200 million years ago during the Ice Age, when Vermont's Green Mountains were heaved by the cold to "Himalayan heights," in the words of one geologist. Eventually the earth's crust collapsed like a soufflé, and some of the mountains slid west, creating the Taconics, the spiny range that separates western Massachusetts from

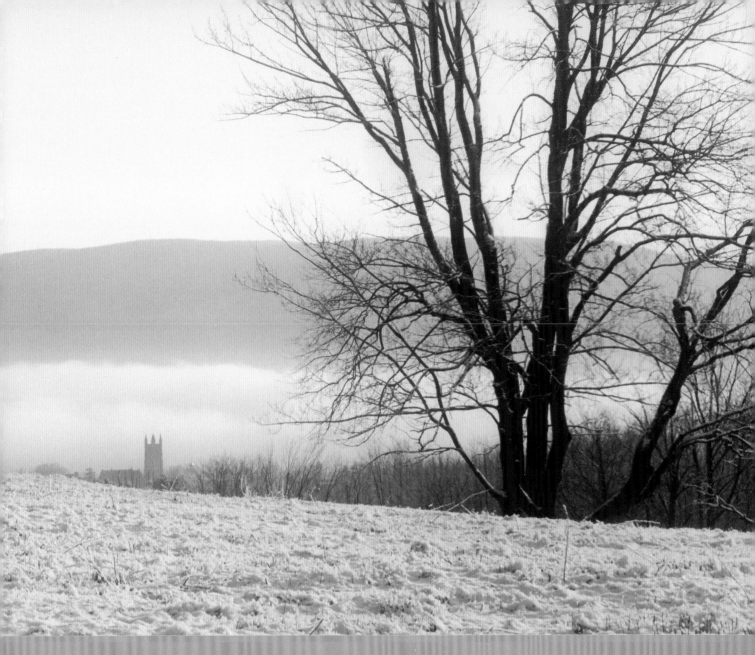

New York State. Stone Hill is a splinter of this tectonic hiccup, made of lime-
stone studded with white and rose quartz.

Originally, the hill divided Williamstown into two villages, until the
locals followed an old Indian trail and cut a road over the top of it, then
cleared the forest for timber and farmland. A century ago, the vistas atop
Stone Hill revealed great swaths of open pasture; with the decline of agricul-
ture, more trees are visible today. Something in the New England sensibility
responds to the pastoral order of farmland amid woods. Ralph Waldo

LEFT AND ABOVE The Clark's extensive walking trails wind through forests, fields, and pastures
OPPOSITE The experience of "art in nature" manifests itself in many ways

Emerson, the American poet-philosopher, saw a moral good in the georgic landscape and the collaboration of man with the great god-force Nature. Be it an orchard in neat rows, a farmstead, or "a stone seat by the wayside," rustic productivity, wrote Emerson, "makes the land so far lovely and desirable, makes a fortune . . . which is useful to [the] country long afterwards." At the Clark, the visitor can test this idea—there is even an old stone bench along one of the hiking paths to invite such contemplation.

The Clark is unique in the way it partners with the serene beauty of the Berkshire landscape, and Stone Hill is the enduring symbol of this symbiosis.

The Institute retains the rural ecology of Stone Hill, trimming encroaching scrub brush and allowing a local farmer to graze dairy cattle, and actively preserves it against development. Great museums are traditionally

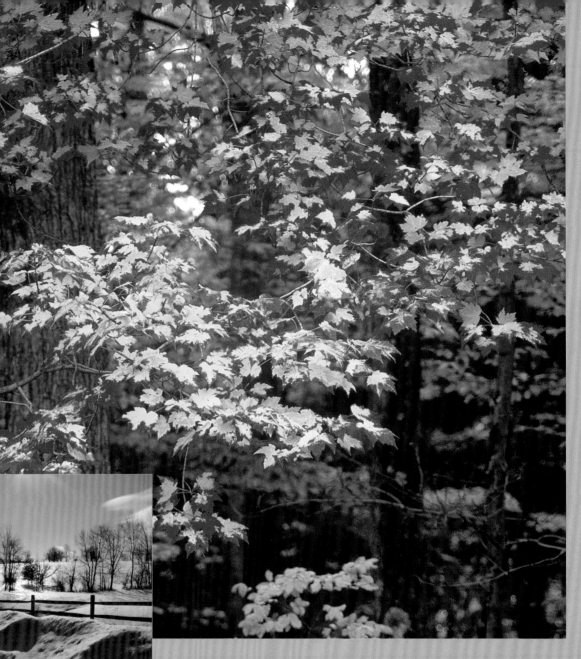

ABOVE AND OPPOSITE  The changing seasons of
New England only enhance the beauty of the
Clark's stunning setting
FOLLOWING PAGES  Autumn leaves blanket the East
Lawn; an early snow provides winter fun

founded in great cities, as temples of human achievement, and, just as much, escapes from human pressures. The Clark is unique in the way it partners with the serene beauty of the Berkshire landscape, and Stone Hill is the enduring symbol of this symbiosis. As much as the Renoirs, Monets, and Homers, the hill a resident poet once proclaimed "our local mountain of paradise" is integral to the Clark's identity. Whether viewing Stone Hill's sloping rise from the museum, or looking down at the Institute from its high crest, the impression of one is indivisible from the experience of the other.

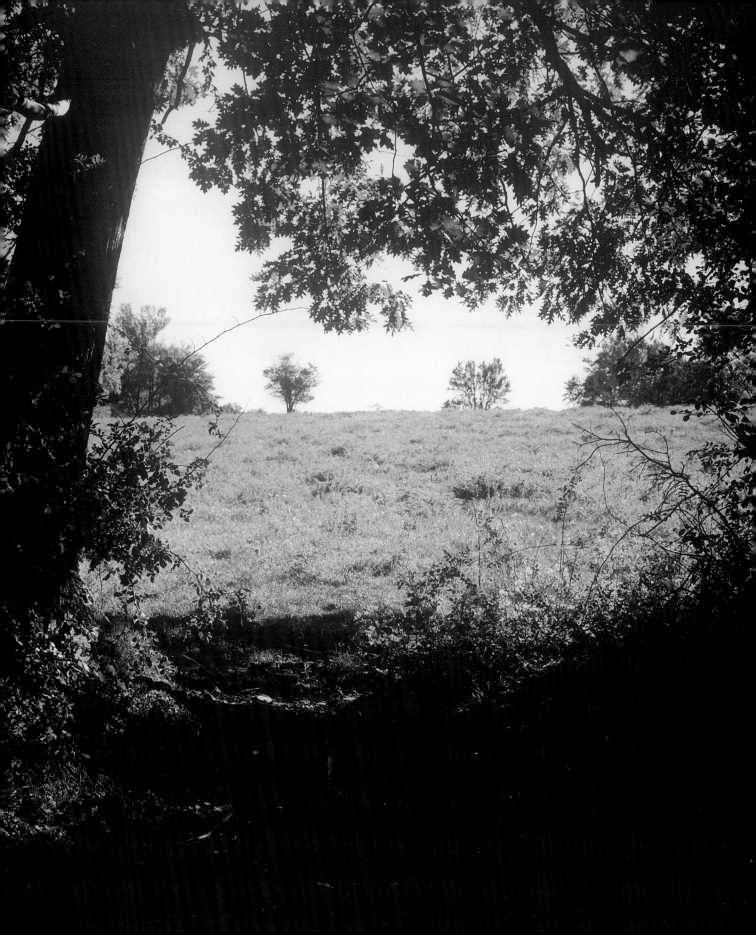

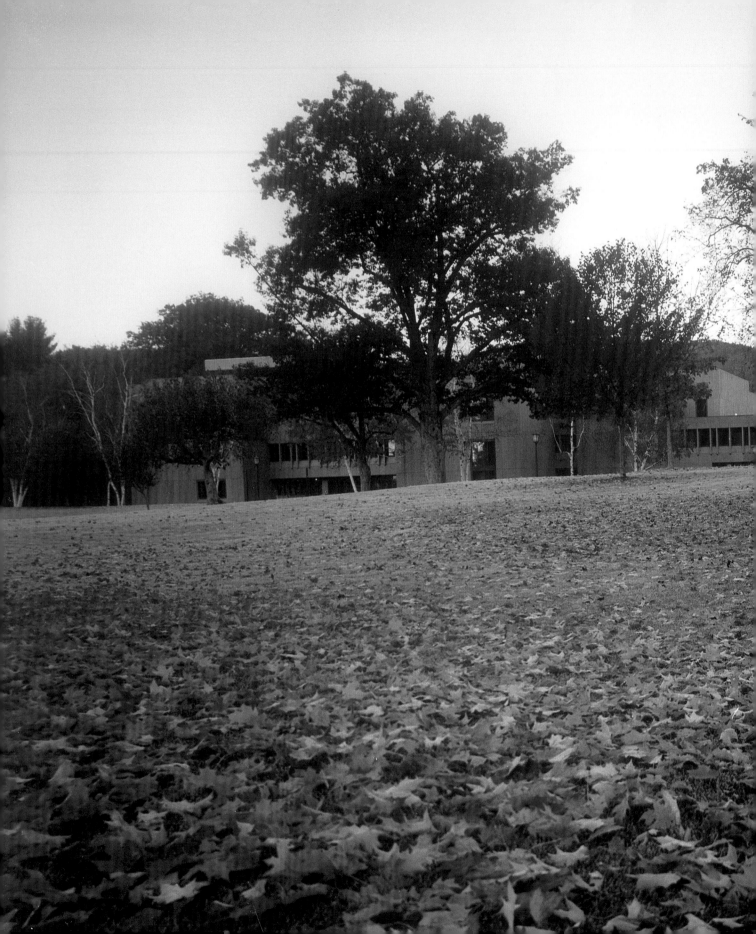

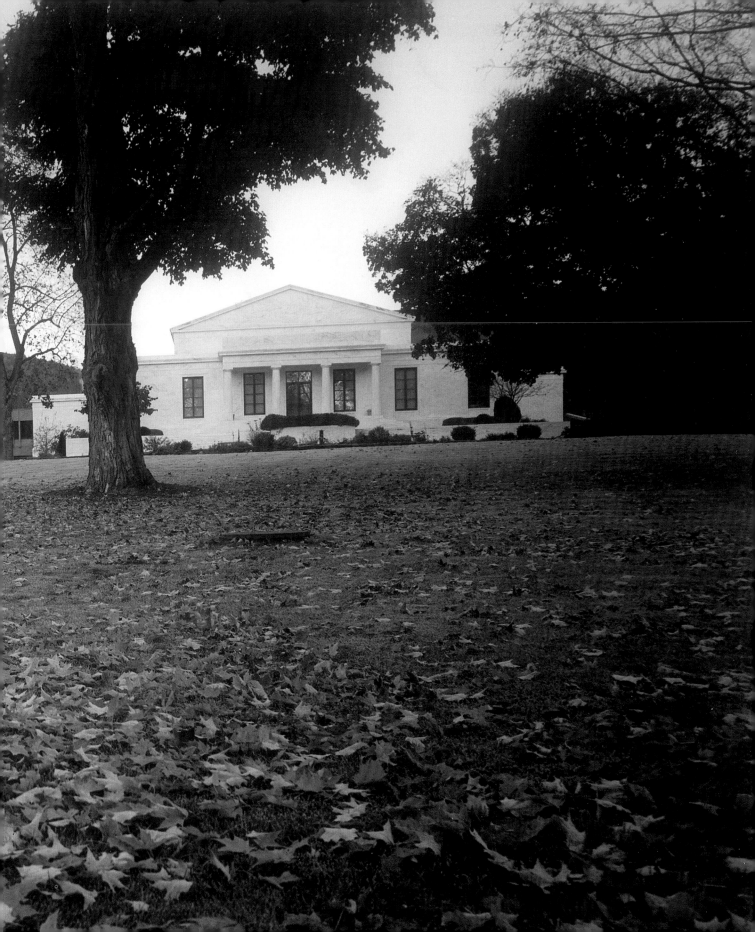

ABOVE  Spring blossoms at the entrance
to the marble building
BELOW  Sterling and Francine Clark at the
Institute's opening in 1955
BELOW LEFT  The Institute's corporate seal reflects
Sterling Clark's lifelong interest in horses

# The Founders and Their Legacy

Opening day for the Clark was May 17, 1955. In the Institute's archives is a grainy home movie of the event, filmed on that spring morning at the ribbon-cutting ceremony that inaugurated the museum. The reel shows Francine Clark, a distinguished woman in white gloves and a flowered hat, being escorted up the marble front steps, followed by her husband, Robert Sterling Clark, his face stony from decades of playing the curmudgeon.

On this day, though, Clark was far from stony. Beaming and strutting, he stopped before a small group of guests, doffed his hat, and bowed. Mrs. Clark cut the wide ribbon stretched across the columns of the entrance, and as the loose ends fluttered and parted, a private delight passed between husband and wife and they smiled all the more. It had long been the Clarks' intention to leave their art collection to the public, and with the creation of their "mooseum," as Mr. Clark affectionately called the Institute, they fulfilled that plan in high style. It was a dream, this fine building of theirs, and it had come true.

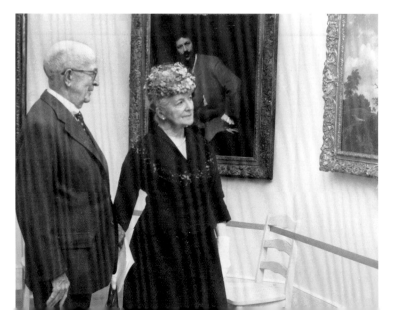

Francine was partner and inspiration to her husband, but by all accounts Sterling was the force behind the couple's extraordinary collection and bequest. The son and grandson of millionaires, Mr. Clark spent the first half of his life pursuing adventure and the second attending to pleasures. Born in 1877, he grew up in Manhattan and on his family's estate in rural Cooperstown, New York. After graduating in 1899 with an engineering degree from Yale, Sterling spent six years in the Army, seeing action in the Philippines and earning a Silver Star for valor during the Boxer Rebellion in China. In 1908, he returned to China, leading a research expedition on horseback through the mountains of that country's northeastern wilderness, an adventure he documented in a detailed and lively account, *Through Shên-Kan*.

Clark's years in the military imbued him with a leather-hard gruffness, which he singularly combined with the refinement of a Parisian sophisticate. He admired good food, fine wine, great art, and beautiful women, and occupied himself with numerous interests and activities. Clark was a shrewd financier, an amateur chef, an avid outdoorsman, and a student of military science. An aficionado of racehorses, he established thoroughbred farms in Normandy and Virginia, where he bred "Never Say Die," his champion

ABOVE  Sterling Clark (center) at the family farm in Cooperstown
BELOW  Sterling Clark served as an officer in the Army during the Boxer Rebellion in China; in 1908–9 he led a scientific expedition into northeast China, which he chronicled in the book *Through Shên-Kan*

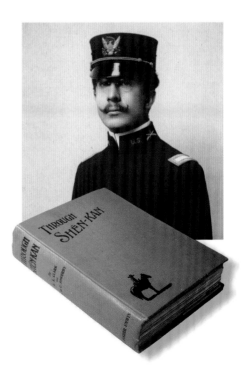

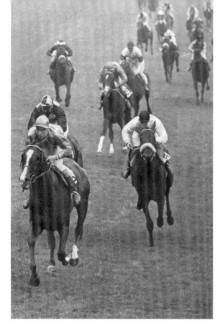

ABOVE  Sterling Clark's racehorse Never Say Die won England's prestigious Epsom Derby in 1954

OPPOSITE  *Self-Portrait*, c. 1897, by Pierre-Auguste Renoir
BELOW  Edward Clark, Sterling Clark's grandfather, was the business partner of inventor Isaac Singer and established the family's fortune

three-year-old and winner of the 1954 Derby at Epsom Downs, Britain's premier race. (Clark's passion for thoroughbreds was so complete he put an image of a racehorse on the official seal of the museum he built.)

Clark's grandfather was Edward Clark, a solemn New York attorney. In 1848, Edward Clark met Isaac Singer, an erstwhile thespian with a prodigious family (he's said to have fathered eighteen children by multiple women) and a knack for inventions. In 1851, when Singer perfected the continuous-stitch sewing machine, the libertine genius retained Clark to untangle patent complexities and help guide his invention to production. The two men were an odd couple, but the partnership they founded became the Singer Manufacturing Company and made both of them rich. Clark, who was something of a marketing genius, devised a system of letting customers pay "on time," in credit installments, which allowed more people to afford Singer machines. The elder Clark was also a successful New York City real estate developer, building, among other projects, Manhattan's famed Dakota apartment house. When he died in 1882, Edward Clark was among the wealthiest men in America, leaving an estate worth approximately fifty million dollars.

The fortune passed to Edward's youngest and only surviving child, Alfred Corning Clark, a dedicated patron of art and music who died at fifty-two, in 1896. When Alfred's widow Elizabeth passed away in 1909, the family fortune was distributed among the couple's four sons, Edward, Sterling, Ambrose, and Stephen.

Each of the four brothers manifested distinctly different temperaments. Edward, the oldest, lived the quiet life of a gentleman farmer in Cooperstown. He is remembered there even today as a public-minded philanthropist who, among other contributions, built the region's most important hospital. Third-born Ambrose was a flamboyant horse-breeder and raconteur. According to legend, when "Uncle Brose" broke a hip at age seventy, he wouldn't board the ambulance until someone brought him his cigar and champagne for the ride.

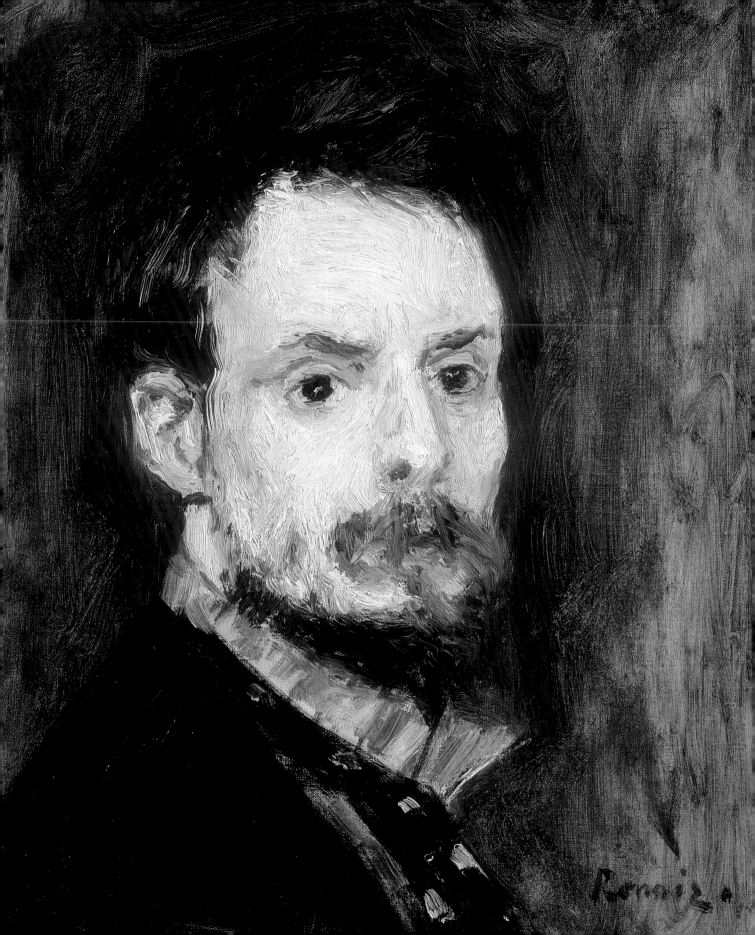

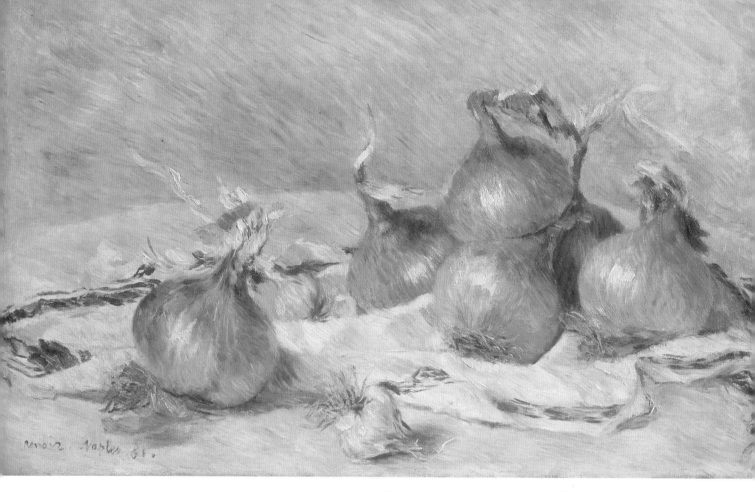

Stephen Clark, the youngest, was the businessman and civic leader in the family, running the Singer company and serving on the board of numerous charitable organizations. He was a collector of art, though with considerably more modern tastes than his older brother Sterling. He bought Eakins and Hopper, Cézanne and Matisse, and was for a time president and chairman of the board of the Museum of Modern Art in New York. Stephen also purchased, for five dollars, a battered, handmade ball supposedly owned by Abner Doubleday, the purported inventor of modern baseball. Clark himself cared little for the national pastime, and Doubleday's authorship of the sport has long-since been debunked, but the ball became the nucleus of that secular American shrine, Cooperstown's National Baseball Hall of Fame.

"I told her to look, look, and look again and to not let herself be influenced by anyone on her likes and dislikes!!! That there was no book on art which is not biased and experts were so many 'bluffs.' That they only liked pictures which were in fashion."

Sterling Clark was in many ways Stephen's opposite: somewhat more conservative in his aesthetic taste, idiosyncratic in his judgments, and insular in his privacy. After his adventures as a soldier and explorer, Sterling moved to Paris in 1910, where he purchased a house near the Arc de Triomphe. He began collecting art around 1911, when he was thirty-four years old, and continued until his death forty-five years later. He has been called a "self-made connoisseur," following a muse very much like himself, one part field marshal and one part aesthete. He sought the counsel of few advisors and disdained experts with brusque self-reliance. A brief conversation recorded in his diary on April 26, 1945, succinctly expresses his philosophy. He had spent the morning with a young artist friend looking at paintings, and then met with the artist's wife and two companions: "Mrs. Hales asked me what to read on pictures to know how to appreciate them!!!" he wrote, with his characteristic exuberance for punctuation. "I told her to look, look, and look again and to not let herself be influenced by anyone on her likes and dislikes!!! That there was no book on art which is not biased and experts were so many 'bluffs.' That they only liked pictures which were in fashion."

Clark's own eye was astute and eclectic, able to reconcile the wildly disparate styles of a Botticelli Madonna, a Remington cowboy, and a Renoir ingénue. "It is not easy to see," scribbled one perplexed wag after touring the collection, "how a man who bought some of the pictures could have bought some of the others."

His severe judgments and rigid opinions were politically and socially conservative in every way. (In the 1930s, his name was even connected to an alleged scheme to depose President Franklin D. Roosevelt.) In matters of art Clark could be dazzlingly hidebound, cleaving throughout his life to conventions that were already outmoded when he was a boy. Writing of Picasso and Matisse in 1934, he growled, "Dreadful—I would not give $10 apiece for them." In spite of his blind spots, though, Clark remains a compelling, charismatic figure. He lived large and was loyal to his convictions. His dismissals were equaled in their flamboyance by his enthusiasms. Writing

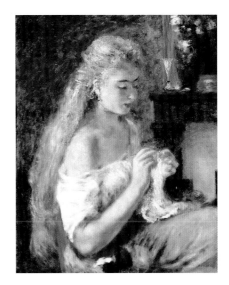

ABOVE AND OPPOSITE *A Girl Crocheting*, c. 1875, was the first of thirty-nine works by Pierre-Auguste Renoir that Sterling Clark purchased; *Onions* of 1881 was reportedly his favorite
BELOW Domenico Ghirlandaio's *Portrait of a Lady*, painted around 1490, was one of the first paintings that Sterling Clark acquired

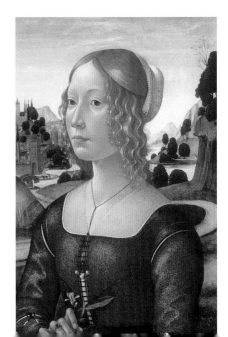

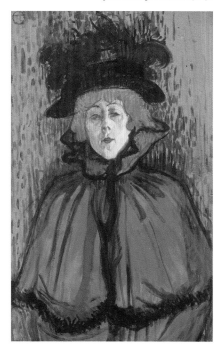

about Renoir, his favorite artist, he cheered, "As a painter I do claim he has never been surpassed—As a colorist he has never been equaled—Of course Rembrandt gave more volume, Van Dyck had more elegance in line, etc. etc. but I would rather live with 20 Renoirs than 20 Rembrandts!!!"

In Paris, sometime around 1910, Sterling met Francine Juliette Modzelewska, known by her stage name Francine Clary. She was a year older than he, an attractive, fun-loving actress with the Comédie-Française, France's most prestigious theater. They were soon inseparable, and married several years later, in 1919. Francine had a daughter when she met Clark, but the couple never had children of their own. They remained devoted to each other throughout their lives. People who knew them recalled that, long after having established New York as their permanent home, they often conversed with each other in French, the language in which they'd fallen in love.

Clark's diaries are filled with numerous admiring references to Francine; she, in turn, was the only person who could sway her husband in his opinions. As the couple collected together, Francine played an increasingly important role. When it came to assessing pictures, Clark described her as "an excellent judge, much better than I at times"; eventually, she was approving every major purchase. One dealer recalled that the couple arrived at his gallery together each Saturday, and if a French painting was under consideration, it was Francine who led the discussion. We don't know exactly what criteria influenced her judgment, though in one prominent example it may have been her background on the Paris stage. She took an immediate liking to the expressive, limelight-green portrait of the dancer Jane Avril by Toulouse-Lautrec and persuaded her husband to buy it that very day. Avril had been a regular at the Moulin Rouge at the end of the nineteenth century, and Francine may well have seen her perform the graceful, melancholy dances that made her a celebrity in Montmartre.

By the end of World War II, Sterling and Francine's collection numbered upward to five thousand items, spread among their New York apartment, their Virginia horse farm, and storage galleries arranged by the dealer

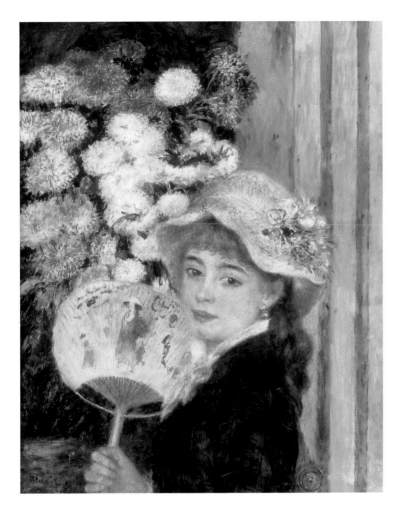

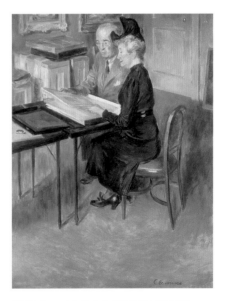

ABOVE A 1942 painting commissioned from the American artist Paul Clemens shows Sterling and Francine Clark looking through their print collection at the Durand-Ruel Gallery in New York
ABOVE LEFT *A Girl with a Fan*, c. 1881, by Pierre-Auguste Renoir

Durand-Ruel that housed works removed for safekeeping from their Paris apartment and Normandy farm. In 1946 Clark wrote to a friend, "This collecting business is a disease. I did not realize I had quite so much." Visitors to the couple's luxury Manhattan apartment remember masterpiece on masterpiece leaning against the walls, and one story has Mr. Clark searching for a Manet and finding it stored behind a desk.

Clark considered leaving the collection to several museums, including the Metropolitan Museum of Art, and had long been attracted to the idea of establishing a museum in a Manhattan townhouse, as Henry Clay Frick had done with his Fifth Avenue mansion. He went so far as to purchase

RIGHT In 1947 Sterling Clark purchased property at the southwest corner of Park Avenue and Seventy-second Street in Manhattan in order to build a museum there, but he soon abandoned the idea of a city museum and focused his efforts on Williamstown

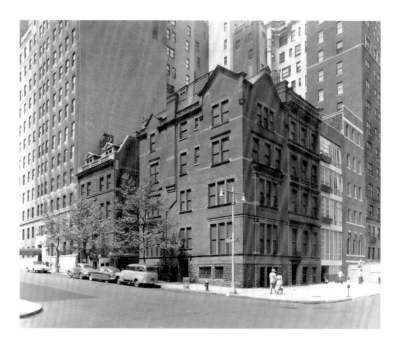

A convergence of circumstances led the Clarks to the Berkshire village. …Williams College, for its part, enthusiastically courted the Clarks and the proposed museum.

three adjacent Park Avenue townhouses expressly for that purpose, and changed his will to establish the "R. Sterling Clark Collection" as a house museum. His conviction to proceed with the idea may well have been dampened by the escalating atomic age, however. Clark had been pro-foundly moved by the events of August 6, 1945, when he wrote in his diary, "Great commotion about the Atomic Bomb—3,000 times the force of TNT!!!!!! 'A great scientific discovery' hailed so by great men in all professions! A great curse, I call it. . . ."

The Clarks had already experienced the destruction of conventional warfare in World War II, when their farm in Normandy had been destroyed beyond repair. As the Cold War intensified fears across America, and New York came to feel increasingly like a target, Sterling revived an idea he'd had more than thirty years before. In 1913, Clark described his vision for a rural museum in a letter to his younger brother Stephen. "You remember the sub-ject on which we had a conversation last year, namely my idea of founding a gallery in Cooperstown?" the missive began. Clark went on to enumerate

several advantages to a country site: "[I]t would help the town," "it would be better lighted," the countryside would be "ideal for landscape painters," and it would provide citizens, particularly children, "the advantage of seeing good pictures." Clark's clarity on these points proved remarkably perceptive regarding the Institute's eventual impact on Williamstown, where his youthful idea took final form.

A convergence of circumstances led the Clarks to the Berkshire village. It was, to be sure, securely remote—in those days, a six-hour drive on back roads from New York. While Clark had spent almost no time in Williamstown, he had family ties there. Grandfather Edward had graduated from Williams College in 1831 and later served as a college trustee, as had

BELOW Construction of the Sterling and Francine Clark Art Institute began in Williamstown in 1952

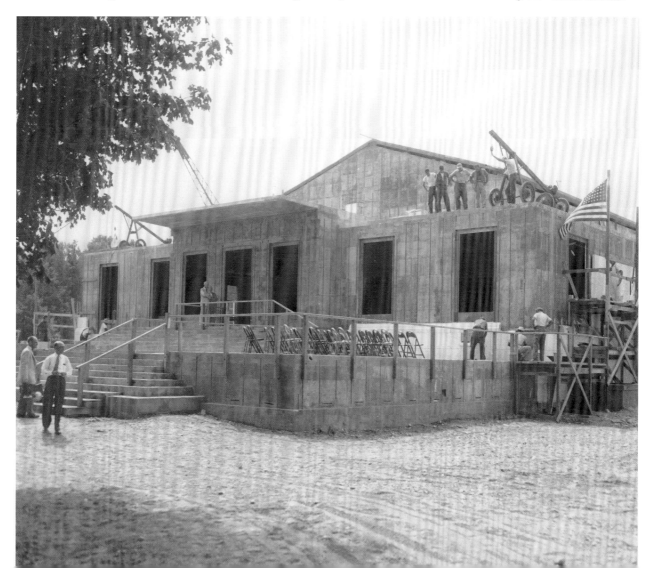

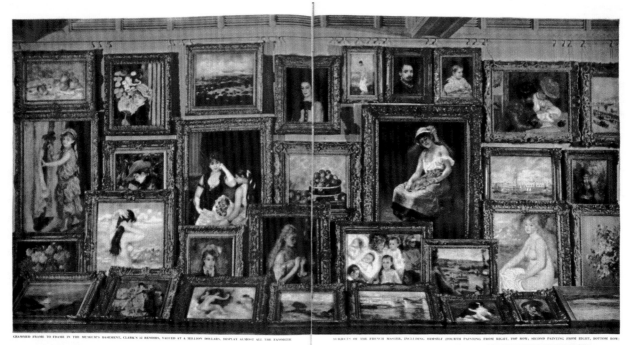

CRAMMED FRAME TO FRAME IN THE MUSEUM'S BASEMENT, CLARK'S 32 RENOIRS, VALUED AT A MILLION DOLLARS, DISPLAY ALMOST ALL THE FAVORITE    SUBJECTS OF THE FRENCH MASTER, INCLUDING HIMSELF (FOURTH PAINTING FROM RIGHT, TOP ROW; SECOND PAINTING FROM RIGHT, BOTTOM ROW)

## A BASEMENTFUL OF     BEAUTIES

### Clark Art Institute unveils a prize portion of     its rich hidden trove

When the Clark Art Institute opened in Williamstown, Mass. in 1955, it exhibited such a modest array of art that it seemed just another small-time, small-town museum. But the institute (right), built by Robert Sterling Clark and his wife Francine to house their collection, is in fact a kind of artistic iceberg, a major part of which still lies hidden beneath the surface. In its basement a wealth of treasure is now being sorted and catalogued so that most of it can be brought into view. Recently assembled there was the dazzling portion shown above: 32 lush and lovely paintings by the great French impressionist Auguste Renoir.

This basement bonanza, which will be on view next month in the galleries, is one of the world's largest private collections of Renoir and the result of 30 years of collecting by Clark. An heir of Singer Sewing Machine millions and the brother of Art Collector Stephen

C. Clark, Sterling did all his buying secretly. Known to dealers as "Mr. Anonymous," he accumulated 400 paintings, 30 sculptures and a $5 million collection of antique silver without an ounce of publicity.

In December Clark died at 80. But his museum keeps growing as art arrives from Clark's various homes. "Every time I think I have everything," says the director, "along comes another wonderful truckload. It's endless."

COLLECTOR Clark spent last years near Williamstown museum.

---

ABOVE *Life* magazine marked the opening of the Institute with an extraordinary photographic spread of works by Renoir in the collection
BELOW Clark Hall at Williams College, built in 1908 with funds from Elizabeth Clark and her four sons (including Sterling), replaced an earlier Clark Hall, which had been endowed by Sterling's grandfather

Sterling's father. Edward Clark also endowed Clark Hall, home to the college's (and the town's) first museum, a "cabinet" of geology and archaeology. When that building became structurally unsound, Sterling, along with his mother and brothers, rebuilt it in Edward's honor. Located on Main Street, Clark Hall remains the home of the college's geology department.

Williams College, for its part, enthusiastically courted the Clarks and the proposed museum. The news of a prominent private collector reached Williamstown through a college alumnus connected to one of Sterling's legal advisors. The old school tie led the alum to contact Karl Weston, Williams' distinguished emeritus art historian and founder of its Lawrence Art Museum (now the Williams College Museum of Art). Weston and a young colleague, S. Lane Faison, Jr., traveled to Manhattan to meet with Clark, and were instantly astonished by what they saw there.

Despite Clark's usual disdain for art historians, he struck up a quick friendship with Weston, who soon became a close advisor. Weston, aided by Williams president J. Phinney Baxter, was influential in persuading Clark to establish the "Clark Institute," rather than simply the "Clark Collection." The difference is a crucial one of institutional vision and scope. A "Clark Collection," focused merely on the art of the original bequest, could quickly have stagnated and had limited impact beyond its four walls. The Institute, however, offered provisions for continual expansion, in terms of the collection itself and the larger mission. This flexibility, enshrined in the Institute's charter, has been key to the Clark's growth on the world stage as both an esteemed museum and a prestigious research center.

The building that Sterling and Francine erected was a monument to the classical virtues of balance, harmony, and order. With its four Doric columns and white marble exterior, the Institute is a latter-day temple to the Greek ideal. The young architect who translated these values into stone was Daniel Perry, whom Clark discovered on the far end of Long Island, where he had built several neoclassical school buildings but never a museum. Perry rose to the opportunity, creating a building that emphasizes nobility while avoiding ostentation.

One of the most inviting aspects of Perry's vision is the museum's human scale. In some places its exterior walls are barely higher than a two-story house, and nowhere does the building dwarf the visitor. Its sugar-white marble exterior possesses a comely purity—the stone, quarried in Vermont, gleams in the sun and appears to glow even on the sulkiest days. Inside, the museum's stone, hardwood, and smooth plaster corridors and galleries are both understated and refined.

Sterling Clark died in 1956, and Francine, four years later, in 1960. Today, their names and dates are etched on the marble steps in the front of the building, the same steps they climbed in the 1955 home movie. The inscriptions mark the place where husband and wife lie interred, forever a part of the museum they brought into being.

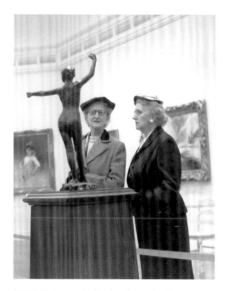

ABOVE Visitors at the Institute's opening in 1955
FOLLOWING PAGES The light-filled Impressionist gallery is a favorite with visitors of all ages

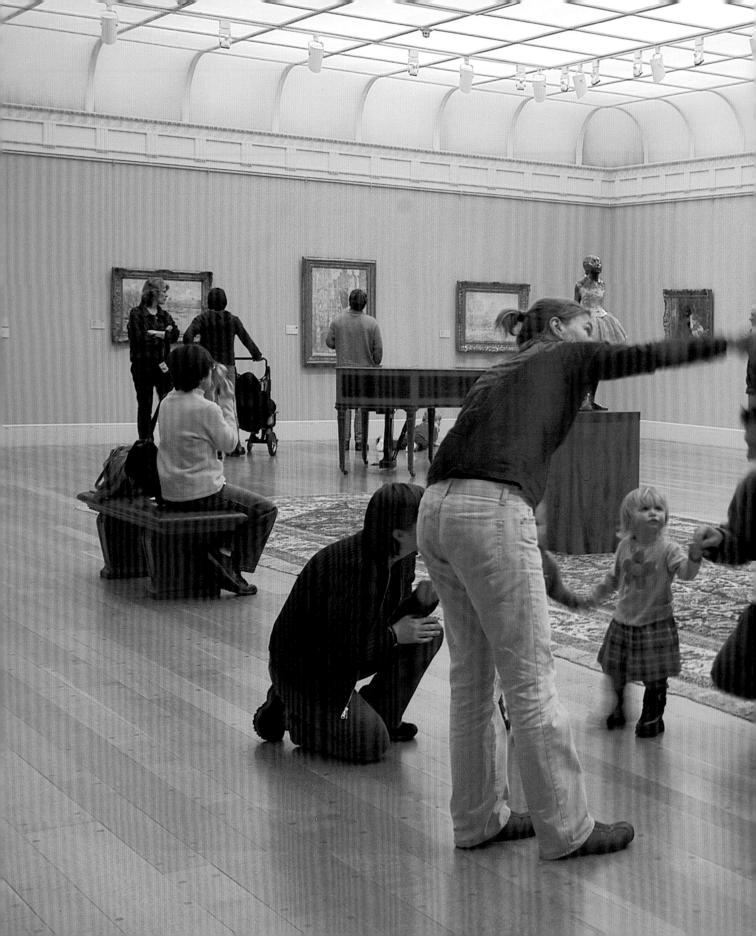

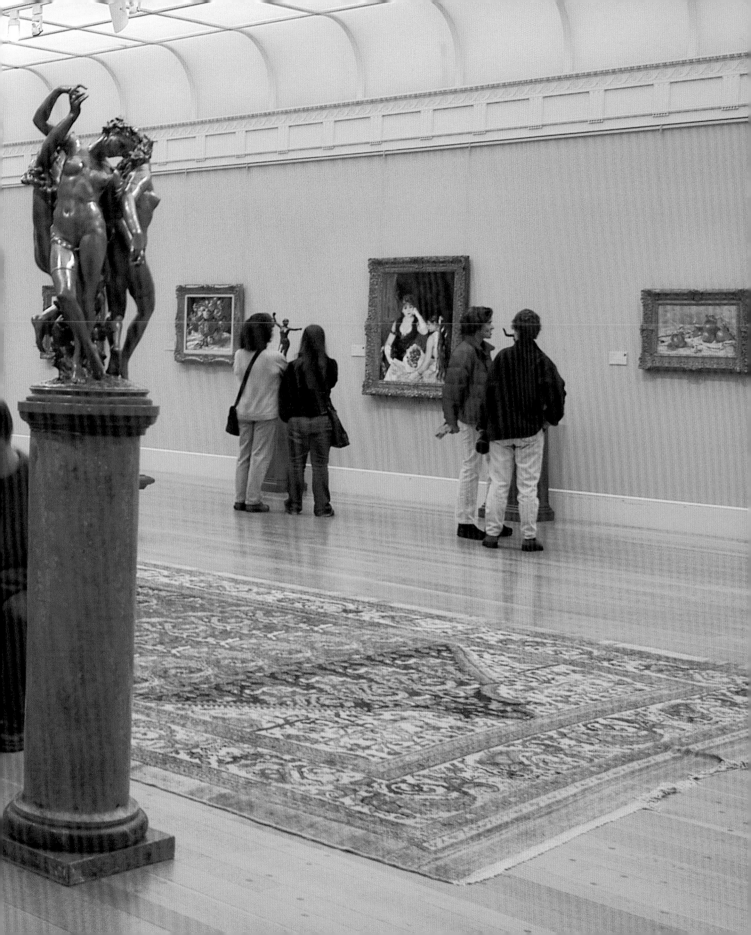

# Decorative Arts

It is only in recent centuries that painting and sculpture became elevated above other media in the visual arts. Before the Enlightenment, such skills as metalsmithing, furniture making, even fabric design, were afforded equal pride of place, and there has never been universal acceptance of the division we take for granted between the "fine arts" and "decorative arts." William Morris, the nineteenth-century renaissance man who wrote poems, painted murals, and designed wallpaper, made this point in an 1877 public address, when he admitted, "I cannot in my own mind quite sever [painting and sculpture] from those lesser, so-called Decorative Arts . . . [I]t is only in latter times, and under the most intricate conditions of life, that they have fallen apart from one another; and I hold that, when they are so parted, it is ill for the Arts altogether."

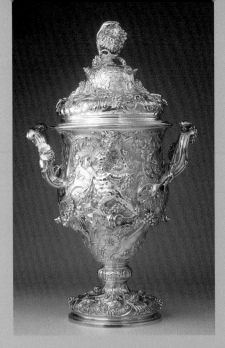

ABOVE *Two-Handled Cup and Cover, c. 1742,*
by Paul de Lamerie
OPPOSITE The opulent soup tureen of 1779–81
by Ignaz Joseph Würth was purchased by the
Clark in 1996 and is one of numerous works
in the collection that have been acquired since the
founding of the Institute
BELOW This unusual plate from 1840 by the
Bohemian firm of Lippert and Haas is a popular
favorite with children who visit the museum
PREVIOUS PAGES The elegant simplicity of American
silver contrasts with the more ornate designs of
English silver of the same period

Judging from the Clark's superb collection of silver, founders Sterling and Francine Clark must have been at least partly in sympathy with Morris. Sterling collected fine silver with the same enthusiasm and acumen he acquired paintings. The precious metal appealed to Clark's aristocratic upbringing and his innate sense of style, and for four decades, from 1913 until the opening of the Institute in 1955, he devoted himself to assembling one of the finest private troves of silver in the country, the highlight of which is a distinguished array of eighteenth-century English, Scottish, and Irish works. Building on this foundation, the Clark today offers a broad range of European and American silver from the sixteenth through nineteenth centuries.

Nowhere is virtuosity of design and brilliance of execution more on display than in the silversmith's art. Fine silver enchants the eye with its elegance and variety, which one confirms with even a quick scan of the museum's eclectic gems. A medieval mazer, or drinking bowl, from about 1500, is constructed of burled maple and rimmed with gilded silver and ornate Gothic calligraphy; a lavish eighteenth-century Viennese soup tureen and stand by Ignaz Joseph Würth features a broccoli floweret lid handle and sea serpent legs; an elegant sugar bowl by the famed American patriot Paul Revere echoes the grace of classical architecture. Silver transmutes domestic items into art objects and transports the imagination to the world of castles, palaces, and estates. Nobles may have commissioned the tankards and teapots, sconces and sauceboats, teaspoons, candlesticks, and serving trays on view, but in the galleries their effect is made available to all.

Significantly, the Clark displays silver side by side with the paintings. The two arts appeal to the eye differently, and mentally switching from the ineffable rewards of a fine

"Whenever English silver was good, it was because French silversmiths came to England!!! . . . Good artisans the English but bad artists."

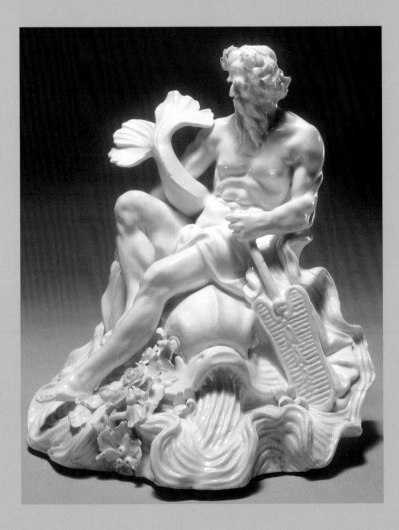

The intricate and delicate *Chestnut Basket with Cover and Stand*, made by the Worcester Porcelain Company around 1770, is one of the many significant works in the Clark's porcelain collection

painting to the pleasures of craft detail that are the delight of silver takes practice. It is a rewarding experience to walk through the galleries focused on the silver alone and observe the surprises that spring to view.

A 1618 hexafoil basin, for instance, is a remarkable bas-relief sculpture, with its miniature biblical scenes and abundant filigree having all been hand-hammered by an anonymous master. Similarly, an elaborate teakettle from 1745/46 is chased with floral festoons, scrolls, shells, and stags' heads, and features

RIGHT *River God,* c. 1750, by the Vincennes Porcelain Manufactory
BELOW The Clark's decorative arts collection includes a choice selection of early American furniture formerly in the George Alfred Cluett collection, such as this Chippendale block-front secretary from around 1770

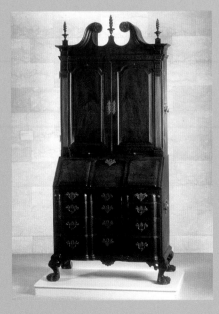

a vignette of a Chinese sage performing the tea ceremony. The handle is ivory, while the base has silver lion's feet. One of the most beguiling aspects of fine silver is its inventiveness, often leaning toward whimsy. Sea monsters, griffins, nymphs, and satyrs abound. The handle of one metal basket appears to grow from the heads of two stoic cherubs. A milk jug is shaped like an egg, a teapot resembles a pumpkin, and four salt cellars take the form of abalone shells held by mermaids (while the accompanying spoons look like tiny scallop shells with coral handles). The figures, plant forms, and decorative flourishes on a two-handled cup by Paul de Lamerie reminds us that Mr. Clark, ever the Francophile, once wrote that "[w]henever English silver was good, it was because French silversmiths came to England!!! . . . Good artisans the English but bad artists." (De Lamerie himself was born in Holland to French parents.)

In addition to silver, the Clark is home to an array of other decorative arts, including furniture, hand-carved frames, blown glass, and a select collection of ceramics. Sterling and Francine's collection of French and German porcelain is particularly fine, containing ornamental demitasse cups and saucers, plates, teapots, and snuffboxes with intricate painted designs and luscious colored glazes. The magnificent *River God,* a figure of a patriarchal water deity seated on a dolphin, was molded in Vincennes, the center of French porcelain manufacturing, around 1747, and its immaculate white surface is a premier example of the "soft-paste" technique that dominated Europe. The bearded idol fits comfortably into the collection, harkening back to antiquity, and forward to the mythological subjects of the nineteenth-century academic painters so popular at the Clark.

BELOW  The Albert and June Lauzon Collection of Early American Glass provides an excellent sampling of rare objects, such as this Masonic flask by the Keene Glass Works in Keene, N.H., from around 1817–25
BELOW LEFT  A rococo snuffbox from about 1760 by Joseph Richardson, Sr., is one of more than two hundred pieces of important American silver that were part of a bequest from Henry Morris and Elizabeth Burrows in 2003
FOLLOWING PAGES  The east facade in winter

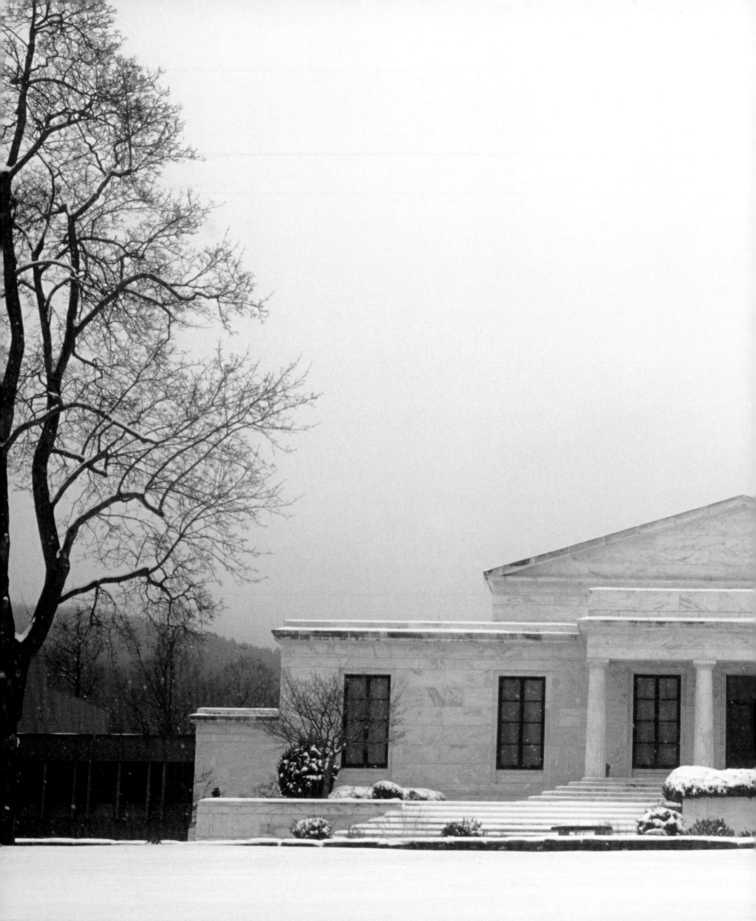

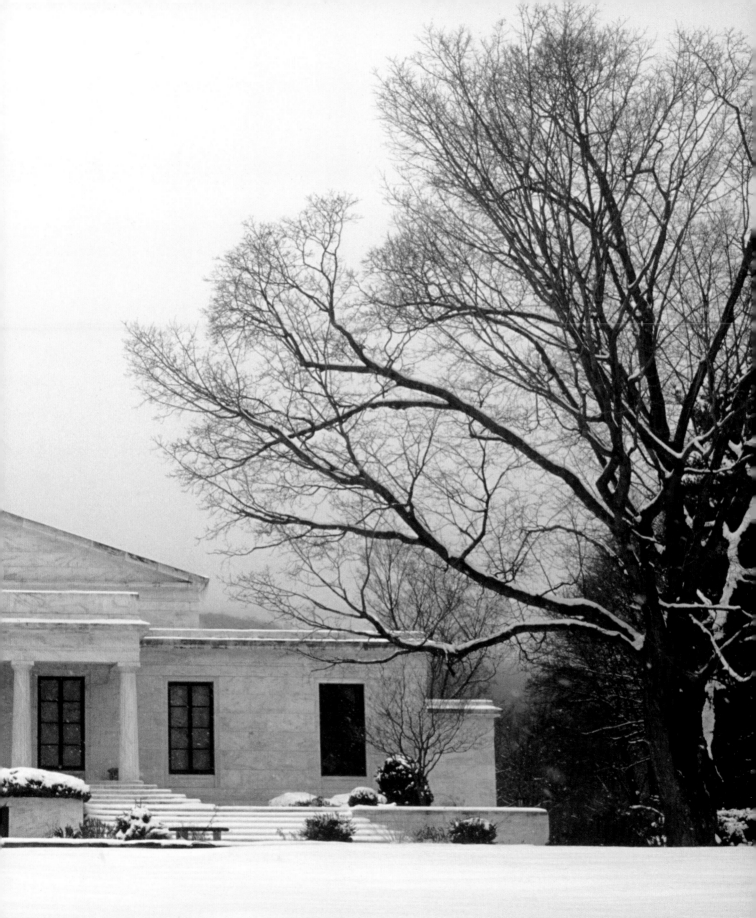

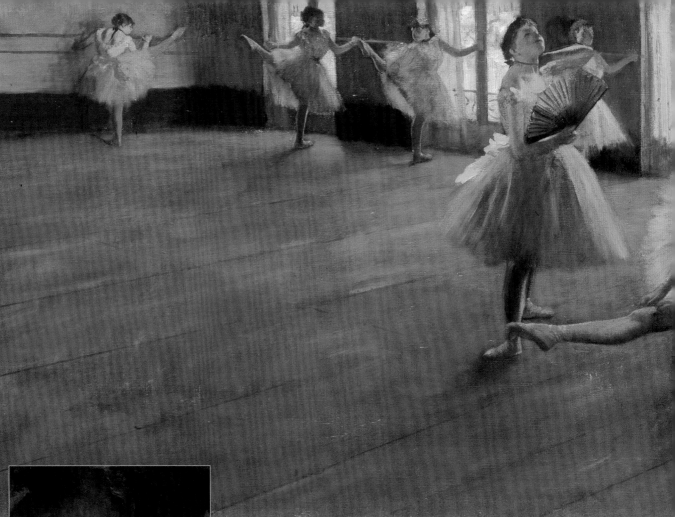

ABOVE The Clark's rich holdings of nineteenth-century art include well-known works by the Impressionists, such as *The Dancing Lesson* from about 1880 by Edgar Degas, as well as important works by academic artists of the same period, such as *Seated Nude* of 1884 by William Bouguereau

## A Walk through the Galleries

As a museum, the Clark has a distinctly appealing intellectual character that contains separate, even contradictory, ideas and synthesizes them into a meaningful whole. The collection presents with equal esteem the radical vision of Edgar Degas in a painting like *The Dancing Lesson* and the virtuoso conservatism of William Bouguereau in that painter's *Seated Nude*. Sterling Clark would praise a painting for being "good of its kind," prizing craftsmanship, imagination, and painterly vitality over style.

The Clark remains similarly open-minded today, and manifests synergy in many ways—in its mix of neoclassical and modern buildings, its cosmopolitan sophistication and New England charm, its pre-modern collection and postmodern scholarship. The juxtaposition of competing aesthetics makes available new connections, new discoveries, new conclusions. The Clark does not promote any single, exclusionary ethos. True, its collections reach only to the beginning of the twentieth century and cannot reflect the tumultuous artistic climate of the past hundred years. But even here the Clark has extended itself, entering into partnership on cutting-edge exhibitions with the Massachusetts Museum of Contemporary Art (MASS MoCA), the large contemporary art facility in nearby North Adams. Even the arrangement of the Clark's paintings in the galleries eludes the traditional view of Western art as an inevitable progression of styles telescoping one from another. Here, salon

ABOVE The Clark frequently collaborates with the Massachusetts Museum of Contemporary Art (MASS MoCA) in nearby North Adams, cosponsoring exhibitions and supporting installations such as *Tree Logic* by Natalie Jeremijenko

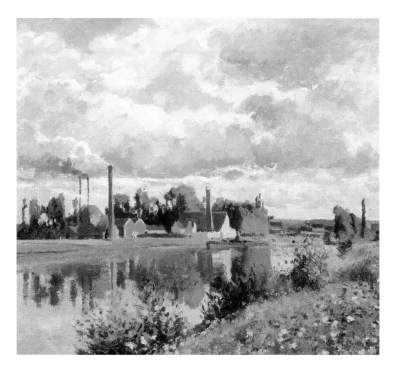

painters are adjacent to the Impressionists, Gothic and Renaissance masters hang steps away from Toulouse-Lautrec and Gauguin. The Clark presents art history as a crowded tale of individuals—some good, some great, some offbeat—at play in the fields of art.

Director emeritus David Brooke has noted that the Clark is "a collection to wander around and discover on your own. You shouldn't approach it conventionally as a museum—'oh, we've got to go see this piece or that one,'" he advised. "You have to succumb to its charm and eccentricity, to its small rooms and long galleries."

The main entrance to the Institute opens onto a high, bright interior courtyard, a busy crossroads lobby containing the museum shop, bookstalls, café tables, and visitor services. In one corner is a splendid auditorium for lectures, films, and classical concerts. Across the way, the art library is open to anyone, no appointment necessary. In addition to some 200,000 volumes on the history of art and 700 journals and periodicals, the library bears visiting for its main-

"You have to succumb to its charm and eccentricity, to its small rooms and long galleries."

floor reading area, where a two-story wall of glass looks out on the Institute's south lawn and century-old stand of red oaks.

The Clark collection is compact enough to view in a single visit yet rich enough to reward return trips. The galleries have an air of relaxed formality, due in part to such domestic touches as fine silver, furniture, small sculpture, fireplaces, even a brace of pianos. (The grand piano in the Impressionist gallery was purchased for Francine while she and Sterling lived in Paris, and the extravagantly carved, scrolled, and gilded marvel in the salon gallery was designed by Sir Lawrence Alma-Tadema for the New York mansion of millionare Henry Marquand.) The paintings are also nearly all sized to fit into a home setting, adding to the intimate atmosphere.

From the street the Clark may look like a temple, but inside it can feel more like a chat room. Visitors amble from gallery to gallery with the leisurely air of people in a park. Here, a mother guides her daughter through the finery of Renoir's *Girl with a Fan*; in a nearby gallery, a pair of teenagers consider

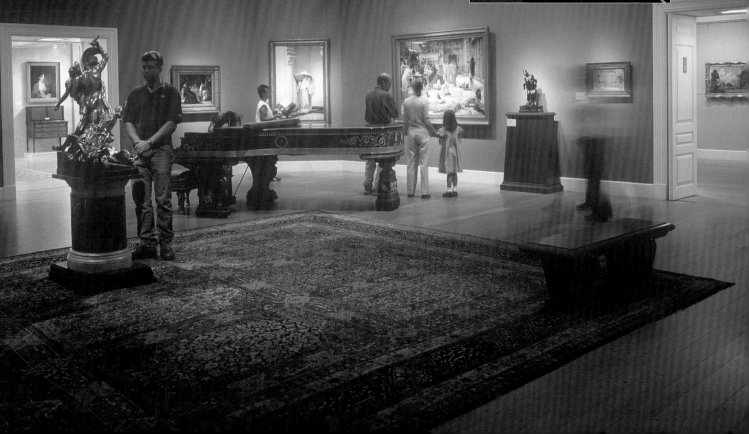

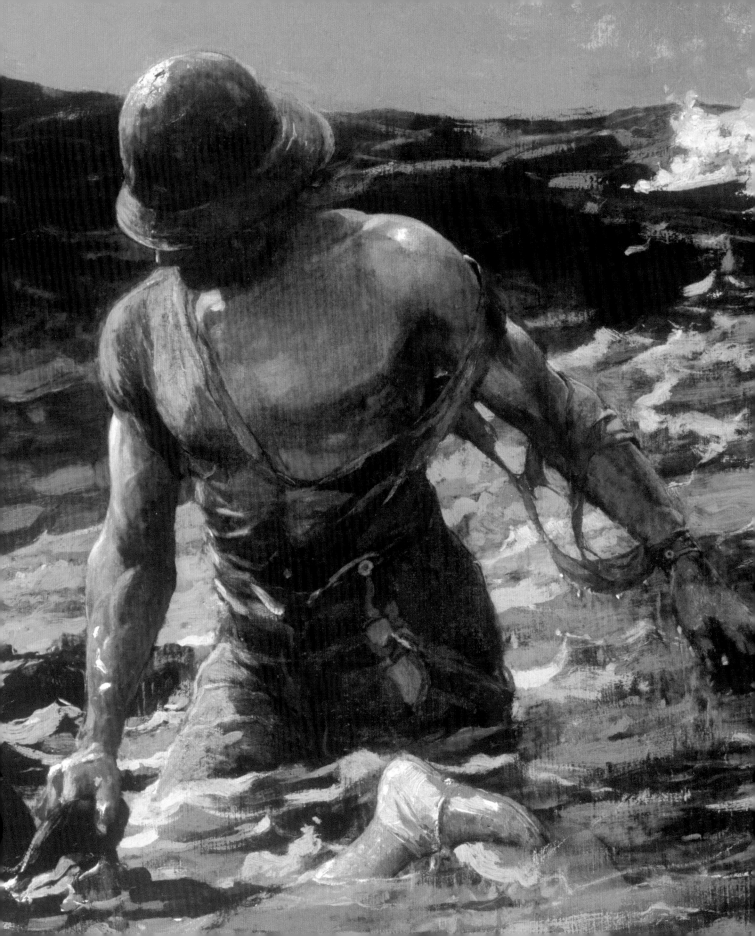

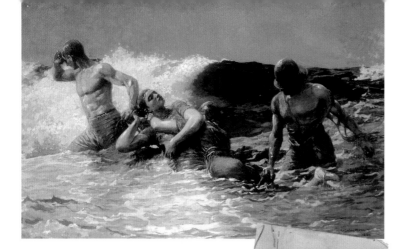

the execution scene in Luca Signorelli's *The Martyrdom of Saint Catherine of Alexandria;* while around the corner, three friends amiably debate Goya's portrait *Asensio Juliá*.

The collection can be considered in several ways. One can organize it by date, beginning around 1317 and extending into the early 1900s, with the vast majority of works falling between 1820 and 1890; or by school: Italian Renaissance, Northern Renaissance, English, Spanish, American, and, exceeding all others combined, French; or by subject matter: portraits and figure studies, landscapes and exterior scenes, still lifes and interiors. The attentive visitor will quickly notice that Sterling Clark had a private fondness for three themes: rural and outdoor subjects; horses and hunting; and above all, young women. He amassed more than ninety paintings of this last motif, plus another dozen mother-and-child pictures.

Of the approximately five hundred objects on display in the museum at any one time, about three-quarters are from the founders' collection, though a significant number of works, including many of the museum's most important paintings, are later acquisitions. While the specific combination of pictures on display changes, the basic organization of the galleries remains more or less constant. A ground-floor gallery is the preserve of American paintings: seascapes and Adirondack scenes by Winslow Homer, cavalry riders and Indian scouts by Frederic Remington. An eighteenth-century gallery

ABOVE AND OPPOSITE  Winslow Homer's 1886 painting *Undertow* is one of more than two hundred works by the artist in the collection, including a series of preparatory drawings for the spectacular surf scene
BELOW  *A Woman Arranging Her Hair*, 1885–86, by Berthe Morisot

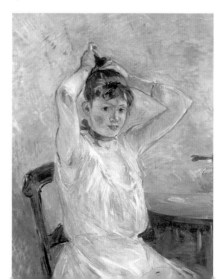

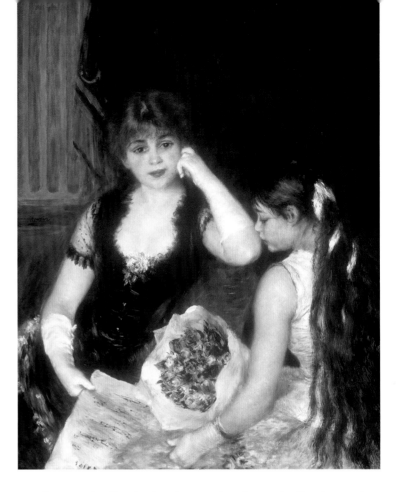

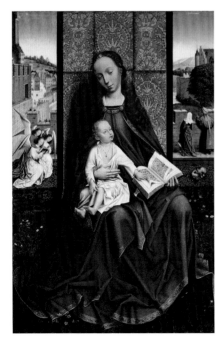

contains cavorting Tiepolo cherubs, rosy laundresses by Boucher, and an opulent array of silver. Three galleries of Old Masters divide, broadly, into seventeenth-century landscapes and still lifes by Jacob van Ruisdael, Claude Lorrain, and contemporaries; sacred and secular panels by Piero della Francesca, Domenico Ghirlandaio, and others from the Italian Renaissance; and Netherlandish canvases by such artists as Hans Memling, Quentin Massys, and the enigmatic figure known as "The Master of the Embroidered Foliage."

A curious sidebar to the collection is a diminutive gallery of so-called "boudoir" paintings, all purchased by Mr. Clark. These nineteenth-century genre scenes of young women playing guitars, singing to parrots, promenading in the street or gazing into space, reflect a slightly prurient, Victorian-era feminine ideal now long outmoded. They are also, on the whole, expertly painted, in particular those by the Italian Giovanni Boldini. An adjacent, octagonal-shaped room is given over to a grouping of dreamy

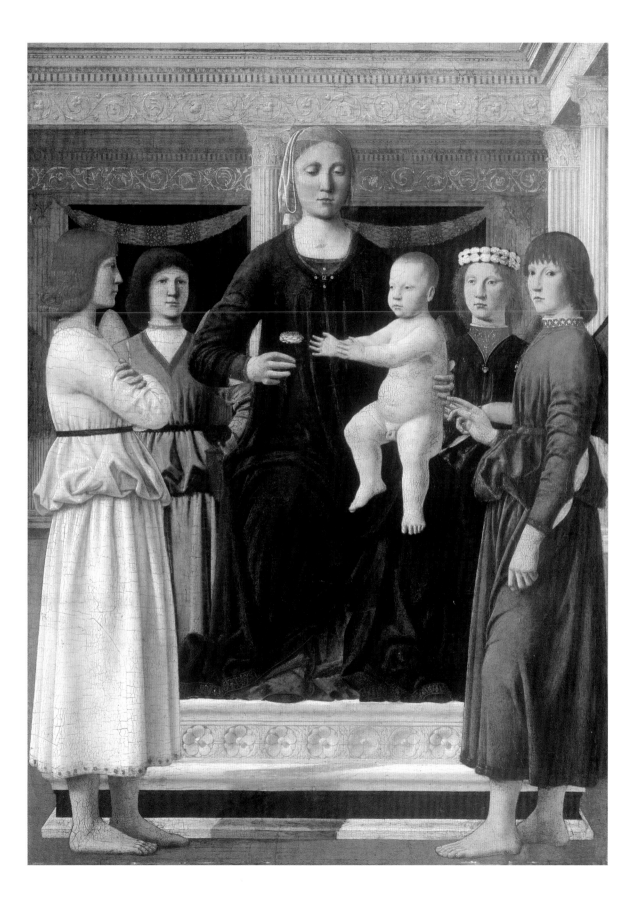

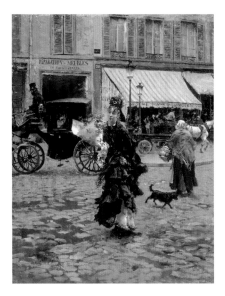

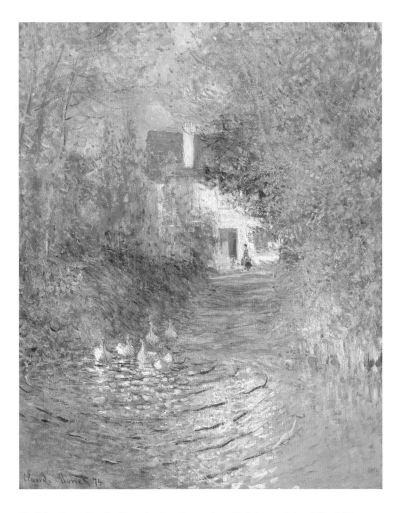

ABOVE *Crossing the Street*, 1875, by Giovanni Boldini
RIGHT *The Duck Pond*, 1874, by Claude Monet

ABOVE *The Blue Dress*, 1861, by Alfred Stevens

Parisian beauties by the nineteenth-century Belgian painter Alfred Stevens, anchored by a quartet of fantasy portraits of women representing the four seasons. Stevens provides a good example of Mr. Clark's zeal for selected artists, some good, some great. Clark amassed twelve works by the skilled but minor painter Stevens, the most in any collection outside the artist's native country. He also bought six oils each by Monet and Pissarro, ten by Homer, a dozen Sargents, and, leading all others, thirty-nine paintings by Renoir.

The original museum building's floor plan reflects the design of a grand estate. Until the 1970s, visitors entered through colonnaded front doors into a shiny marble antechamber, now a gallery. This opened into a

main exhibition hall, which in turn led to a luminous indoor courtyard. Period rooms complete with furniture surrounded the two central paintings galleries. Today, the two large rooms constitute the heart of the permanent collection, with the Impressionists filling the courtyard and nineteenth-century academic painters in the adjoining space.

The Impressionist court is easily the Institute's most celebrated gallery. The museum's single largest room, it is made even more monumental by a vaulted glass ceiling and decorative wall frieze. It is hard not to feel cheerful amid the gallery's bright array of canvases, notably the beguiling gathering of ingénues by Pierre-Auguste Renoir: *A Girl Reading, A Girl Crocheting, A Girl with a Fan, At the Concert, Blonde Bather,* and the languidly sensual *Sleeping Girl with Cat.* Joining Renoir are Claude Monet, who besots the eye with pink and green in *Spring in Giverny,* summer blue in *The Cliffs at Étretat,* and autumn gold in *The Duck Pond*; Berthe Morisot, whose portrait *A Girl Arranging Her Hair* is striking in its directness; and Camille Pissarro, whose *Port of Rouen, Unloading Wood* revels in its subject matter of contemporary commerce. In the center of the room stands a bronze casting of Degas's *Little Dancer of Fourteen Years,* a poignant figure both for her innocence and the visible ravages of her life.

ABOVE *Piette's House at Montfoucault,* 1874, by Camille Pissarro
BELOW *Sleeping Girl with a Cat,* 1880, by Pierre-Auguste Renoir
BOTTOM AND FOLLOWING PAGES The intimate scale of the Clark's galleries fosters an atmosphere of relaxed contemplation

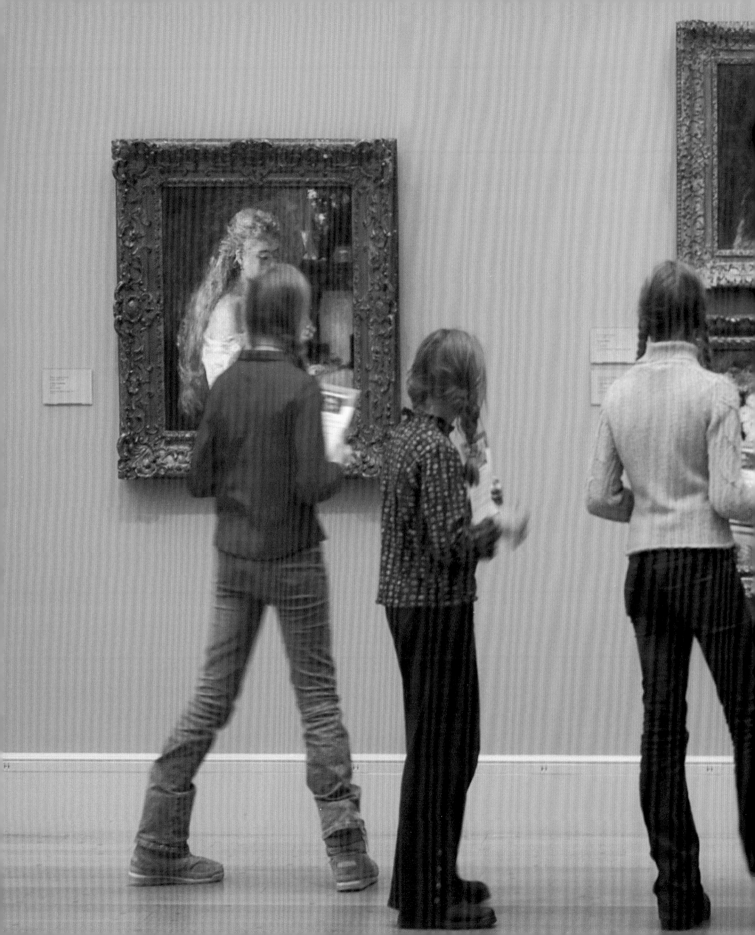

ABOVE *Fumée d'ambre gris (Smoke of Ambergris),* John Singer Sargent's masterpiece from 1880, is one of a dozen works by the virtuoso American artist in the Clark collection

There was a time when it seemed impossible to embrace both the progressive ethos of Impressionism and the neoclassical traditions of the French academy—Sterling Clark was one of the few in his day who did it without apologies. The Impressionists were early champions of modernism; they espoused spontaneity, innovation, and candor, and rejected the art of the Salon, with its meticulous draftsmanship, exotic subjects, and heightened dramatics. Today, the Clark's star trio of unrepentant academics— William Bouguereau, Jean-Léon Gérôme, and Sir Lawrence Alma-Tadema—are no longer guilty pleasures. Our eyes appreciate how diligently they worked to achieve the astonishing realism in their pictures, and their showmanship reminds us of Hollywood. Never mind that the scenes are far-fetched, they have become perennial favorites—the *Arabian Nights* spectacle of Gérôme's *Snake Charmer,* the dreamy sentimentality of Alma-Tadema's *Women of Amphissa,* and the boisterous sensuality of Bouguereau's *Nymphs and Satyr.*

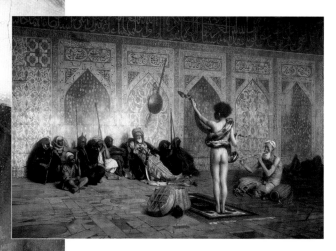

ABOVE *The Snake Charmer*, c. 1870, by Jean-Léon Gérôme
BELOW *Little Dancer of Fourteen Years*, 1880–81,
by Edgar Degas

The museum's most popular painter may well be the
American expatriate John Singer Sargent. Raised and schooled in
Europe, Sargent adopted the tightly rendered accuracy of the academy
and combined it with the vividness of Impressionism. His paintings are
full of dash, but their glamour never sacrifices deeper meaning. His
shimmering white-on-white *Fumée d'ambre gris* penetrates below the
surface of its own exoticism to the sacredness of the Muslim
woman's incense ceremony. *Portrait of Carolus-Duran,* as sincere
as it is brilliant, presents Sargent's teacher and mentor with a heart-
shaped face and expression of dignity and resolve; the artist dedicated
the work in French, "To my dear master Monsieur Carolus-Duran, with
great affection."

The museum is home to a small but fine collection of sculpture, led
by the tender *Bacchus and Ariadne* by Aimé-Jules Dalou, the tragic mythology
of Pio Fedi's *Abduction of Polyxena,* Auguste Rodin's heroic *Man with*

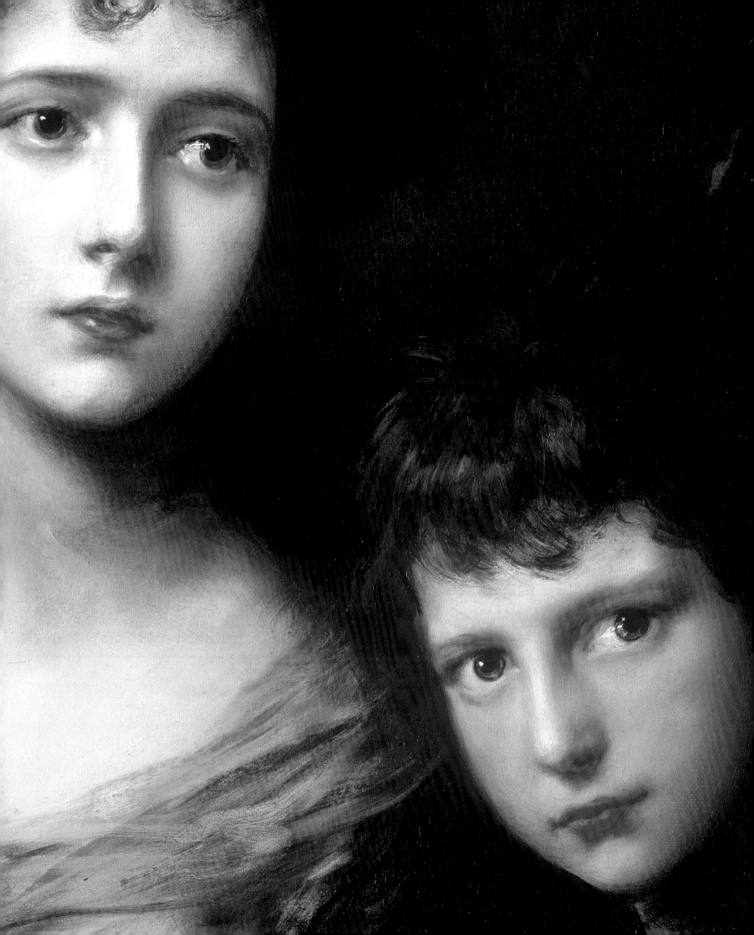

*Serpent,* and the full-gallop pathos of Frederic Remington's *The Wounded Bunkie.* Degas's *Little Dancer* is joined by several bronze castings of horses by the same artist. A gallery of prints, drawings, and photographs features changing exhibits from the collection, and special galleries are devoted to English and European silver and European porcelain.

One definition of a masterpiece is the perfect alignment of subject matter, artistic sensibility, and technical execution. Jacques-Louis David's *Count Henri-Amédé de Turenne* captures the balance of exiled bereavement and stoic dignity in the eyes of the count, a refugee of Napoleon's vanquished army. Set against a backdrop of ashes and flame, the psychologically probing *Trumpeter of the Hussars on Horseback*, by Théodore Géricault, portrays a Hungarian mercenary surveying a landscape in which hope itself has been incinerated.

Few portraits are as lovely or haunting as *Elizabeth and Thomas Linley*, by Thomas Gainsborough. Looking at it, is it necessary to know that Elizabeth, age fourteen in the painting, will end up in a tragic marriage, or that brother Tom, two years younger, will drown when he is twenty-two? All one needs to be moved is to look (and "look, and look again," as Sterling Clark advised) at the enormous sensitivity with which Gainsborough captures the beauty of the emerging young woman and the searching innocence of the boy.

*The Warrior* is one of fourteen "fantasy portraits" by the French rococo genius Jean-Honoré Fragonard. Nothing is known of the model who posed in the yellow smock, red sash, and white ruff, but he appears a man of a distinct verve. Certainly Fragonard was. The surface of the painting is spirited and free-wheeling, a fast-moving stream of brush and paint, which modern analysis has confirmed was painted "wet on wet" in a single session. Painterly freedom is at the heart of Renoir's magnificent *Onions* as well. By infusing the humble vegetables with traces of pink, deep red, citron, green, and bits of blue, the artist has lifted the kitchen still life to symphonic heights.

ABOVE AND OPPOSITE *Elizabeth and Thomas Linley,* c. 1768, by Thomas Gainsborough
TOP *The Wounded Bunkie,* 1896, by Frederic Remington

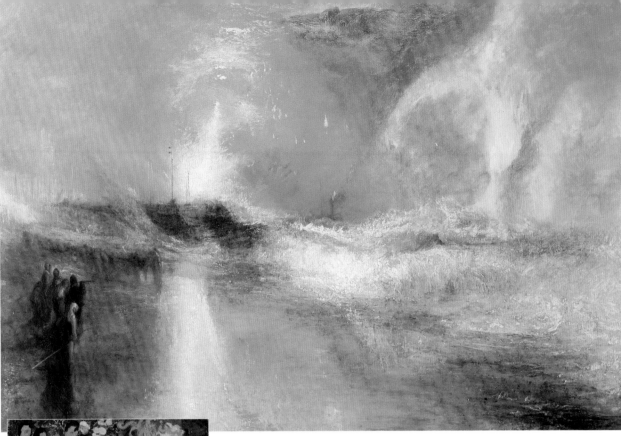

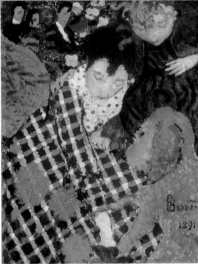

ABOVE AND OPPOSITE *Women with Dog*, 1891, by
Pierre Bonnard
TOP *Rockets and Blue Lights*, 1840, by J. M. W. Turner
was one of the featured works in *Turner:*
*The Late Seascapes*, one of the Clark's
acclaimed special exhibitions
FOLLOWING PAGES Gallery talks are a popular
component of the Clark's public education program;
morning mist rises above the lily pond

Painting is about color, and a day at the Clark is a grand tour of chromatic brilliance. The swirling ochres and blues in J. M. W. Turner's *Rockets and Blue Lights* fully reveal the fury of the stormy seacoast; the silvery greens of Camille Corot's *Bathers of the Borromean Isles* reflect the soft light of summer; the nocturne blue of Winslow Homer's *Sleigh Ride* underscores the painting's expectant mood; and the luminous, muted tones of George Inness's *Home at Montclair* express a transcendent beauty. A corridor gallery on the north side of the museum offers a rich variety of Impressionist color by Manet, Sisley, Degas, Pissarro, and Cassatt.

Nearby is Paul Gauguin's 1894 post-Impressionist work *Young Christian Girl*. The girl's sunflower yellow tunic attracts immediate attention, but notice as well the slashes and strokes of paint in the background, which move Gauguin toward abstraction. Avant-garde motifs are also touched on in the complex textures and patterning of *Women with Dog*, by a young Pierre Bonnard. These two paintings are a fitting chronological finale to the collection. They point in a direction the Clark does not go, toward art movements of a completely new order.

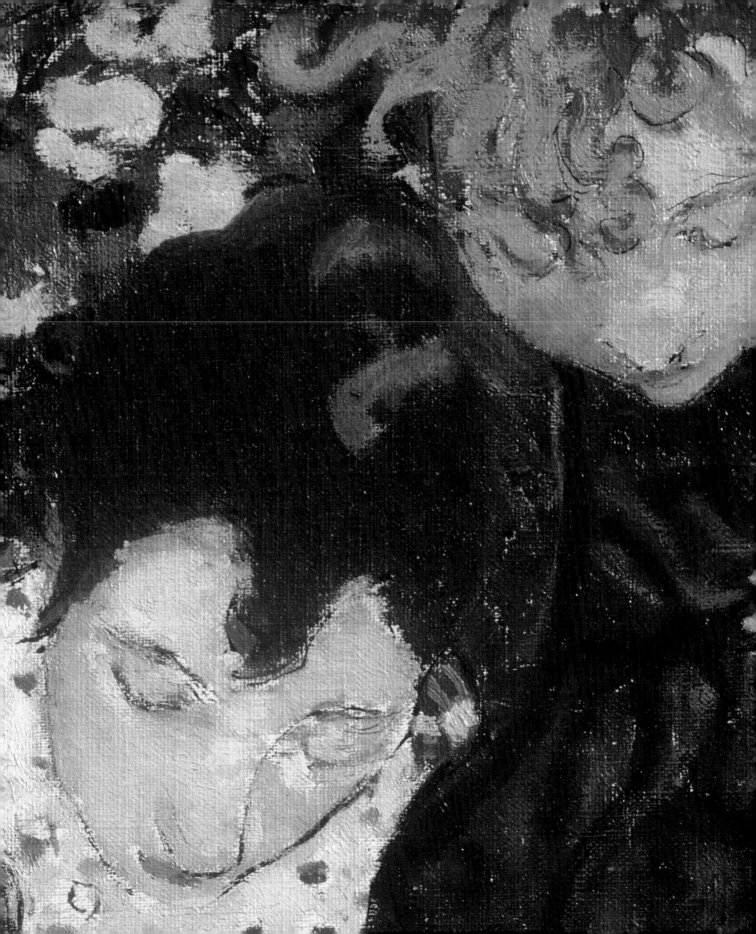

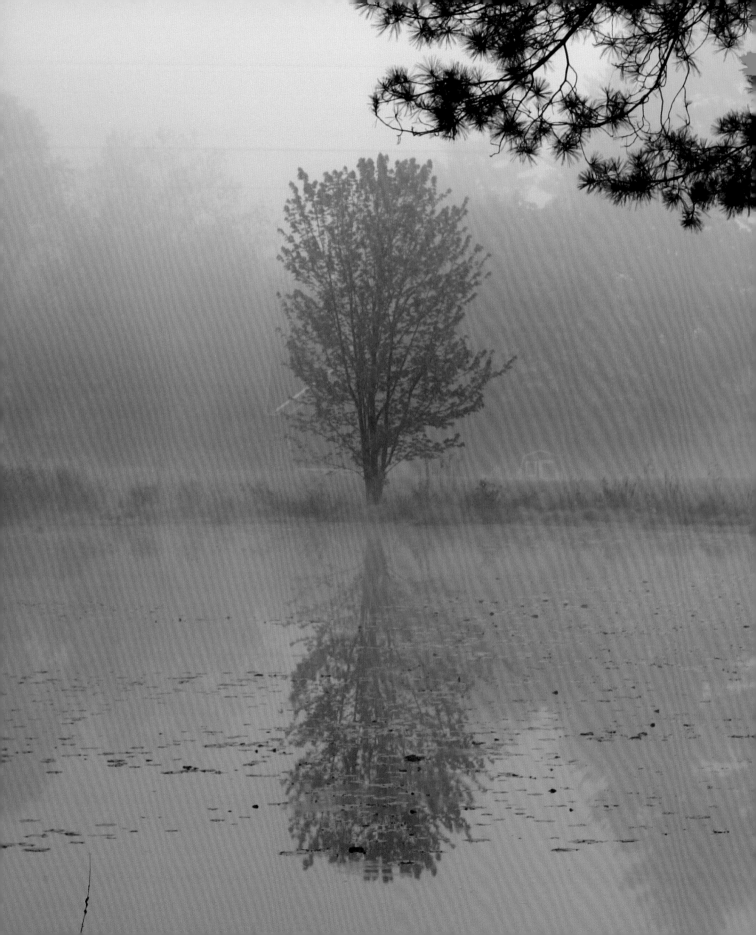

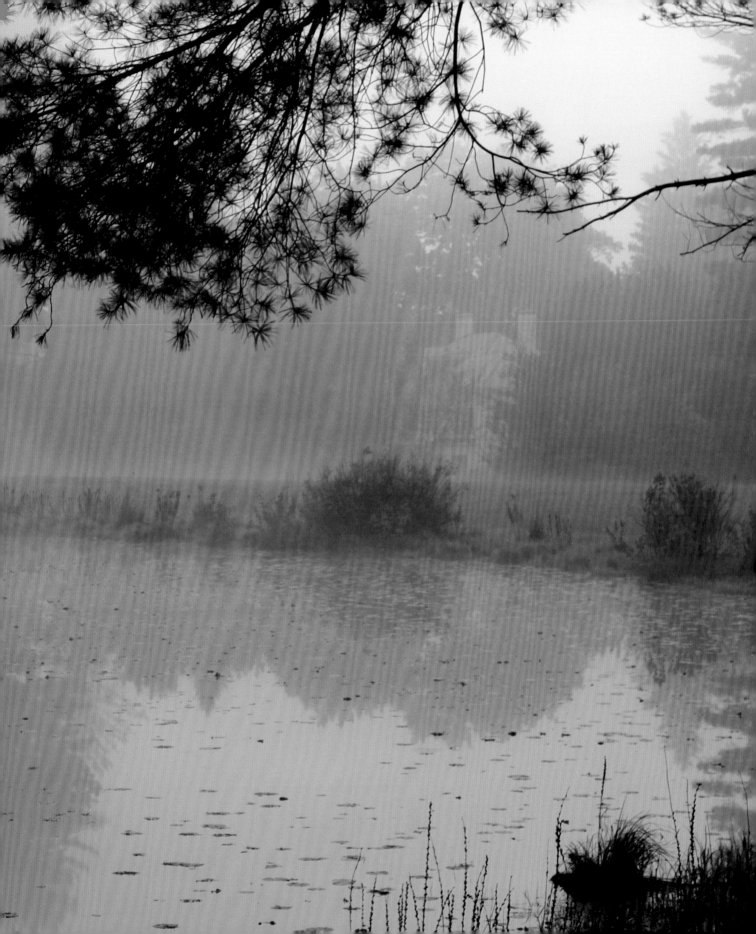

# Prints, Drawings, and Photographs

The theory that drawing is the foundation of art emerged in Florence early in the Italian Renaissance. Drawing, Florentine philosophers opined, was more than a technical skill; it was the essence of the creative process, the means by which the master artist could, through observation and imagination, divine the very structure of creation. This idea was unchallenged in Western art until the era of Impressionism and the rise of the avant-garde.

The Department of Prints, Drawings, and Photographs is by far
the largest and most diverse aspect of the Clark's collection, and is justly
renowned for its corps of master drawings from the fifteenth through eigh-
teenth centuries, the golden age of draftsmen like Tiepolo, Rubens,
Gainsborough, and Watteau. The delicate *Head of a Woman* by Giovanni
Antonio Boltraffio, a pupil of Leonardo da Vinci, is rendered with beguiling
charm in silverpoint. Albrecht Dürer's 1521 ink-and-wash *Sketches of
Animals and Landscapes,* drawn at the Brussels Zoological Gardens, is
among the museum's most appealing masterworks. Among thirty Old Master
gems recently added from the John and Alice Steiner Collection are
Rembrandt's brown ink *Nathan Admonishing David* and a bravura *Studies
of Horses* by the sixteenth-century Mannerist Perino del Vaga.

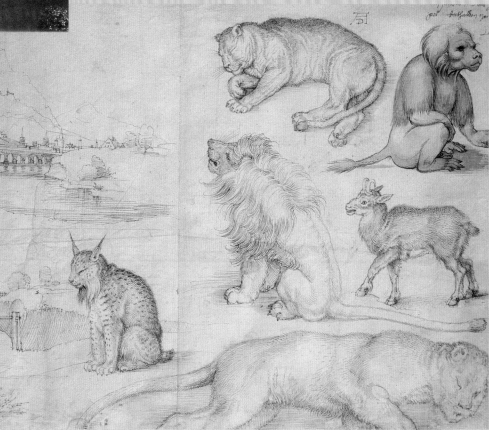

Drawings by Delacroix, Courbet, Daumier, Manet, Toulouse-Lautrec, and others trace the changing styles and philosophies that enlivened the French school in the nine-teenth century. The 1801 nude *La Source,* by Pierre Paul Prud'hon, looks back to the tradition of the Renaissance masters, while studies by Edgar Degas of bathers, dancers, and equestrians, from the end of the century, push at the edge of modernism. The Degas collection totals twenty-nine drawings, thirty-two prints, and sundry other items, including a sheet for an unpublished book.

The Clark's holdings of prints, drawings, and photographs begin in the age of Leonardo and conclude in the age of the automobile.

Watercolors and pastels make up a small but exquisite portion of works on paper. Degas's pastel *The Entrance of the Masked Dancers* and Pissarro's *Boulevard de Clichy, Effects of Winter Sunlight* are considered sig-nal works for both artists. Interesting American objects include a design for a stained-glass window by John La Farge and an epigrammatic watercolor by James Abbott McNeil Whistler. To look at the sparkling *Fish and Butterflies* is to understand why Winslow Homer's watercolors are consid-

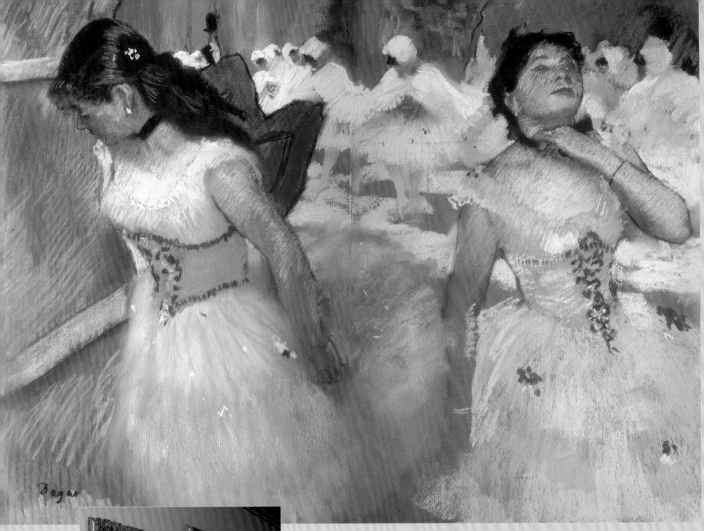

ABOVE Works on paper, such as Edgar Degas's pastel *The Entrance of the Masked Dancers* of 1879, are too fragile to be displayed permanently but may be viewed by appointment in the Print Study Room

ered by many his most poetic works. Along with paintings, journals, even poetry, the Institute owns more than two hundred sketches, drawings, and prints from every stage in Homer's career along with a large number of his Adirondack watercolor scenes.

The Clark's extensive print holdings are dominated by more than three hundred woodcuts, engravings, and etchings by Dürer—a virtually complete collection of the known prints by the German artist. Dürer's tight style contrasts with the erotic, expressionistic Tahitian wood engravings by Gauguin and the allusive lithographs by Manet on Edgar Allan Poe's *The Raven*. Print accessions have added works by artists previously unrepresented in the Clark collection, such as the phantasmagoric *Temptation of Saint Anthony* by Pieter Bruegel the Elder, from 1556, and three rare lithographs by Paul Cézanne from between 1896 and 1898. The Cézannes were part of

a 1962 purchase of the collection of Chicago physician Herbert Michel, which added such names as Van Gogh, Munch, and Picasso to the museum and helped round out the Institute's nineteenth-century holdings.

In 1998, the Clark launched an initiative to collect photography, and since then has acquired more than five hundred works, most from the medium's formative first century. The earliest photographs are a pair of anonymous 1841 daguerreotype cityscapes; the latest, candid street scenes from the 1920s. Photographers represented include Americans Carleton Watkins, Mathew Brady, Eadweard Muybridge, and Alfred Stieglitz; from England, William Henry Fox Talbot, Julia Margaret Cameron, and Roger Fenton; and from France, Charles Nègre, Gustave Le Gray, Edouard Baldus, and Eugène Atget, among many others.

The invention of photography in 1839 exerted considerable change on nineteenth-century painting, even as it became an art form in its

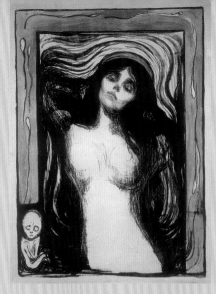

ABOVE  *Madonna*, a lithograph from 1895 by the Norwegian artist Edvard Munch, is one of a number of important late-nineteenth-century prints in the collection
BELOW  The 1911 photograph *Woman Wearing Foxes, Bois de Boulogne*, by Jacques-Henri Lartigue, is one of the latest works in the collection

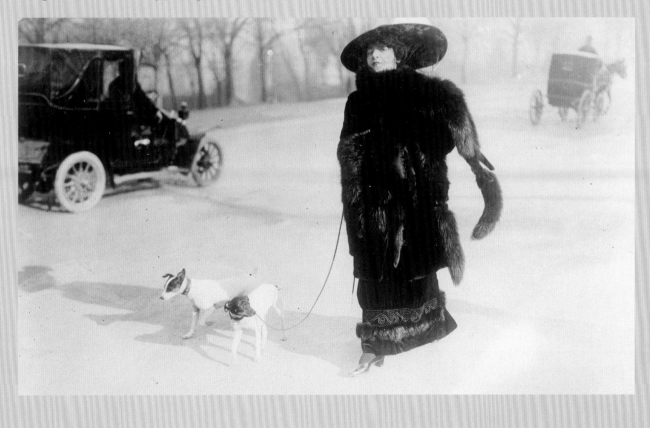

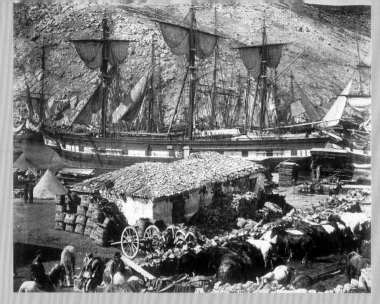

ABOVE *Kitchen of the Imperial Asylum at Vincennes,*
*1859,* by Charles Nègre
ABOVE RIGHT The photography collection includes
works by many pioneers in the field, including Roger
Fenton's 1856 *Harbor of Balaklava, The Cattle Pier*
BELOW Winslow Homer's photograph
*River Scene, Florida,* from about 1904, was made
during a trip to Florida with his brother

OPPOSITE Giovanni Antonio Boltraffio, a pupil of
Leonardo da Vinci, signed his *Head of a Woman* with
his teacher's name, as was common in that time
FOLLOWING PAGES Early morning mist shrouds the
pastures at the foot of Stone Hill; the facade of the
marble building in winter

own right. The photographs engage in a constant rapport with works from the Institute's other collections. Le Gray's seascapes, of which the Clark owns the seminal 1856 *Brig on the Water*, are known to have informed Gustave Courbet's seaside paintings, like the Clark's *Laundresses at Low Tide, Étretat*. Similarly, Baldus's scenes of a French villa mirror the Impressionists' interest in day-to-day life of the French bourgeoisie, and the deadpan directness of Nègre's 1859 *Kitchen of the Imperial Asylum at Vincennes* exhibits the same droll candor of works by Manet.

The photography collection contains a rare 1895 drawing-room portrait of Degas and friends photographed by the painter himself, and a circular snapshot of a swampy Florida waterway made by Winslow Homer around 1904. These works are among the Clark's quirky holdings of photographs made by hobbyists, snapshooters, and anonymous professionals. Such "vernacular photography" speaks eloquently and often wryly of domestic and street life in the late nineteenth and early twentieth centuries, while documenting the fast-moving changes of the era. In Jacques-Henri Lartigue's witty boulevard portrait *Woman Wearing Foxes*, a horse-drawn coach is seen exiting the frame as a touring car enters from the opposite side. The image is a prescient commentary on modern times made by Lartigue when he was just seventeen years old, long before he was recognized as an early master of modern photography. The image reminds us of the remarkable range of the Clark's holdings of prints, drawings, and photographs, which begin in the age of Leonardo and conclude in the age of the automobile.

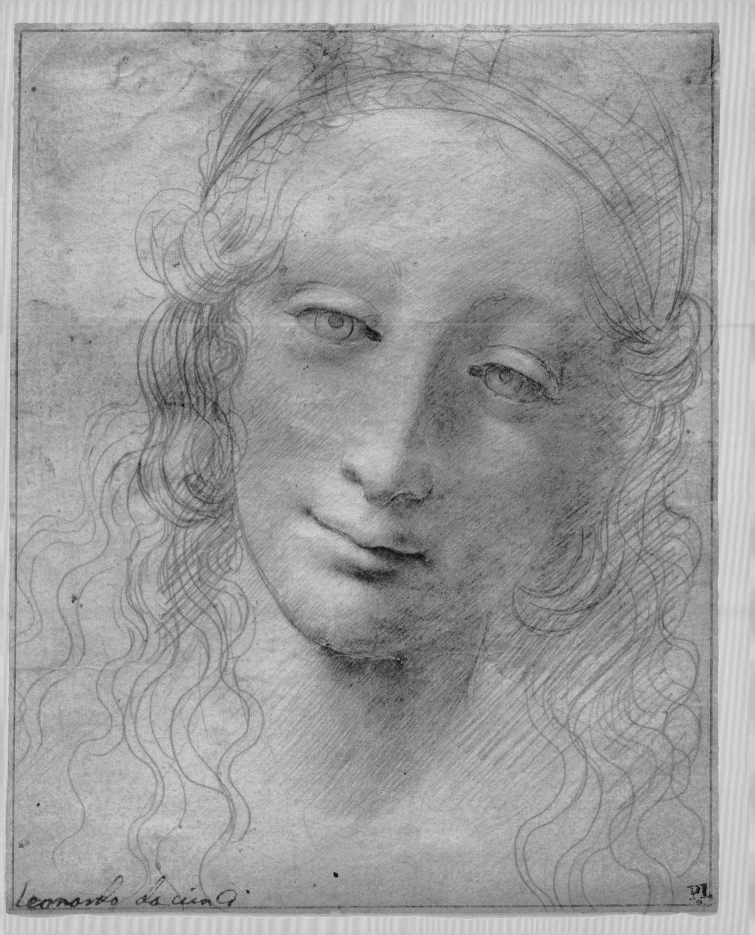

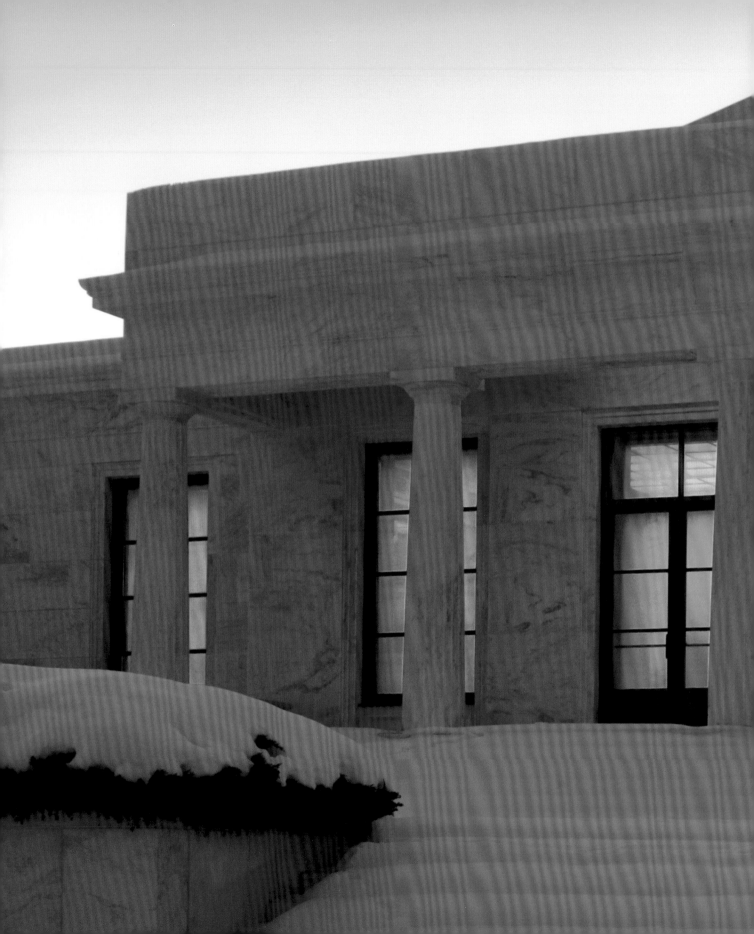

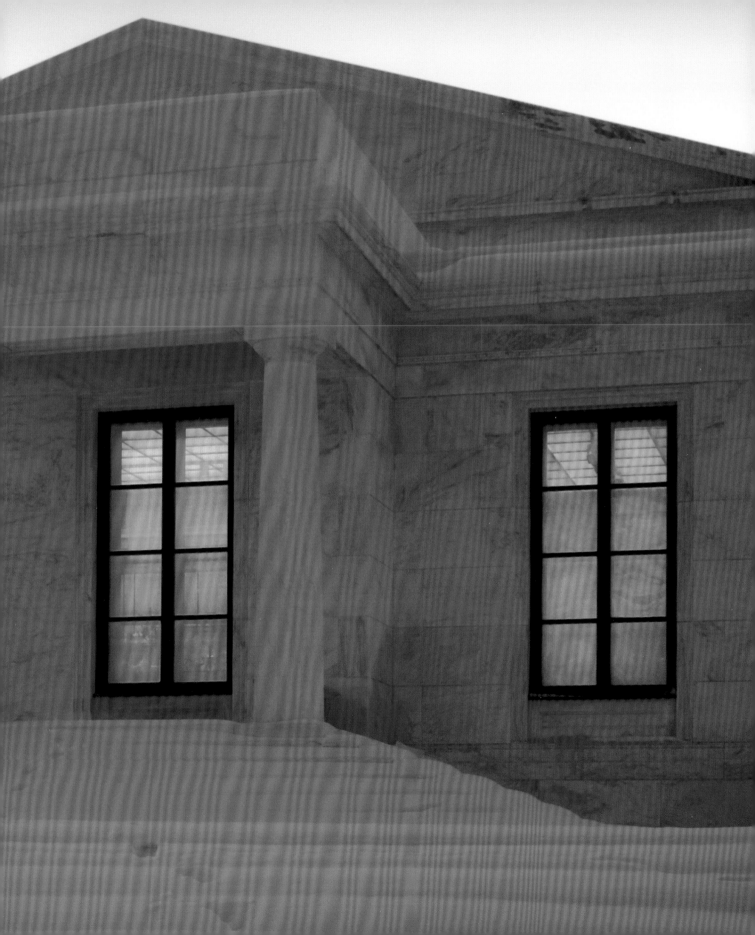

Jacques-Louis David: Empire and Exile
A Clark/Getty Symposium

# THE CLARK

ABOVE Clark Conferences and Symposia examine important issues in art history and visual culture
BELOW AND RIGHT The Clark's research and academic programs provide not only formal conferences and symposia but also opportunities for art historians to gather informally to exchange ideas

# A Greenhouse for Ideas

In the spring of 2003, a group of scholars and writers gathered at the Clark to discuss the Dutch painter Johannes Vermeer. The meeting was small—about a dozen participants—informal, and private, with no audience or guests. The idea was to provide specialists in the field of Vermeer studies an opportunity to gather and freely exchange perspectives on the master from Delft.

"Exchange perspectives," however, hardly goes far enough to describe what took place. "Vermeer to Eternity," as the two-day colloquium was playfully called, turned into a spirited debate of committed and often contradictory opinions, and before long the room was electric with intellectual exchange. While some participants had come to talk about the artist's life and works, others were bent on discussing not the historical figure Vermeer but the figure popular culture has invented as our contemporary notion of "Vermeer." A poet offered his thoughts on the ineffable mysteries of Vermeer light, and skeptical scholars countered with feminist critiques of poetic interpretations.

Ideas were everywhere, floating free, taking root, cross-pollinating. Viewpoints collided at particle-accelerator speeds, and some sparks flew. The event was, in a word, a success.

Welcome to the other side of the Sterling and Francine Clark Art Institute.

Though largely unseen by museum visitors, scholarly activities form an integral part of the mission of the Institute. The Clark is one of a small number of art institutions in the United States that combines a public art collection with a center for advanced research and academics. With its expansive network of public education activities and scholarly events, the Clark's programs encompass all levels of learning, from gallery talks and presentations for children and adults to public lectures, conferences, and symposia, and up through a post-graduate degree program and prestigious professional fellowships. Be it a group conversation on Russian Constructivism, a conference on contemporary architecture, or an individual's research on a specialized field of art criticism, the Clark has become a center for study and discussion on the history of art and the discipline of art history.

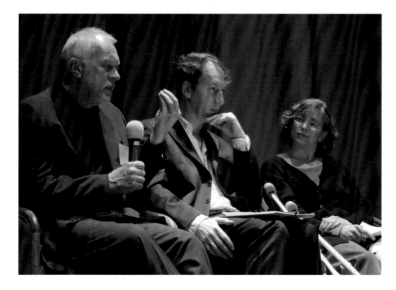

TOP Clark Studies in the Visual Arts, a series of published volumes based on the proceedings of Clark Conferences, ensure that the issues discussed at the Clark reach scholars far beyond Williamstown
LEFT For art historians, curators, and critics, Clark Conferences offer the chance to come together and debate key issues in the field

The Institute's research and academic program operates independently from the museum's curatorial and public education departments, driven not by the agendas of collections and exhibitions but by activities in scholarly circles in the U.S. and abroad. Over the past decade, the Clark has rapidly expanded its role in leading-edge intellectual research and gained an international reputation for its initiatives and resources. In the halls of academe both here and in Europe, the Clark is as widely known as much for its scholarly activities as for its art collection. The Clark Studies in the Visual Arts, a series of volumes based on Clark Conferences and featuring essays on contemporary topics of art history, culture, and museum practice, has become an important resource for academics far beyond Williamstown.

Central to the Institute's growing reputation is the Clark Fellows program, which each year names as many as twenty scholars, critics, and museum professionals to residencies at the Clark for periods of one to ten months. The fellowships offer housing and stipends to support in-depth research and reflection. With its extensive scholarly resources, creature comforts, and natural beauty, the Clark is what one prominent German

ABOVE  The Scholars' Residence includes six apartments for Clark Fellows, as well as communal spaces where scholars can gather informally
OPPOSITE  Detail of *The Rameseum of El-Kurneh, Thebes*, from about 1860, one in a series of photographs taken by Francis Frith during a trip to Egypt
BELOW  The Clark's collection of prints and drawings includes thousands of exceptional works available for study, such as *The Three Trees*, an etching from 1643 by Rembrandt

The Clark is an "intellectual paradise on earth."

scholar called an "intellectual paradise on earth." The program's principal goal is to further understanding of the visual arts and their role in society; it seeks to be a catalyst for new ideas, and courts scholars who traverse intellectual boundaries. The Fellows' interests extend well past traditional high-art connoisseurship into realms of philosophical, political, and social inquiry on all aspects of the visual world, be it architecture, design, advertising, entertainment, pop culture, or the media. As a meeting ground for distinguished minds, the program fosters a dynamic exchange of ideas to function, finally, as a think tank of new theories and perspectives.

While research and curatorial activities of the Institute serve different constituencies, both address the Clark's broader agenda of intellectual

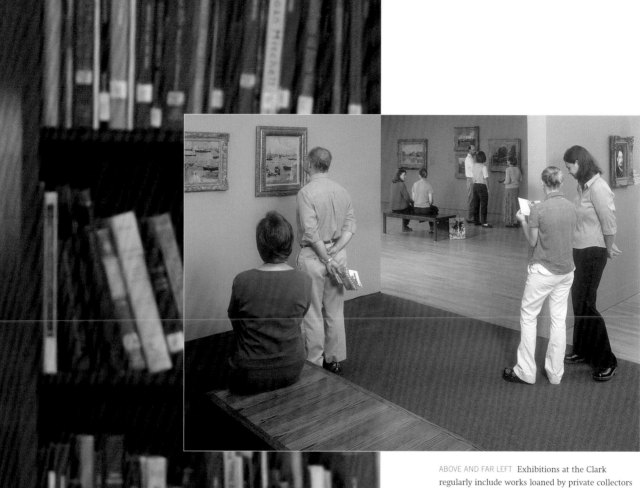

ABOVE AND FAR LEFT Exhibitions at the Clark
regularly include works loaned by private collectors
and major museums from throughout Europe and
the United States
OPPOSITE Students at work in the Clark's art
history library

advancement. The museum's special exhibitions are always more than col-
lections of pretty pictures; they are built around fresh discoveries and occa-
sionally provocative curatorial points of view, and are organized to present
cutting-edge scholarly research to the general public. The shows are often
the work of prominent visiting scholars or involve international partnerships
with leading museums such as the National Gallery in London, the Van Gogh
Museum in Amsterdam, and the Royal Academy of Arts in London. Other
important Clark exhibitions have been developed under the auspices of
FRAME, the French Regional and American Museum Exchange, a consortium
of two dozen regional museums in the U.S. and France of which the Clark is
a founding member.

ABOVE AND BELOW  Many research and academic
programs at the Clark include an open discussion
with the audience, often prompting rich and
sometimes unexpected dialogues
BOTTOM  The critically acclaimed exhibition
*Jacques-Louis David: Empire to Exile*, which included
works like *Sappho, Phaon, and Cupid* of 1809
(The State Hermitage Museum, St. Petersburg),
also included a public symposium

Each year, the Clark hosts leading thinkers and writers on the arts
through its programs of lectures, conversations, colloquia, symposia, and
conferences, all of which enrich the intellectual life of the Institute. Colloquia
bring in up to a dozen specialists at a time for weekend retreats similar to
the Vermeer event. Symposia allow scholars and other experts to discuss the
work of an artist or movement, while conferences look at larger issues rele-
vant to art history and art in culture. Almost all events are open to the pub-
lic, many for no charge.

Among those who take advantage of this procession of dignitaries
are the emerging scholars in the Graduate Program in the History of Art, co-
sponsored with Williams College. The two-year master's program prepares
graduates for careers as academic and museum professionals. The program
is taught by Williams faculty, distinguished visiting professors, and members

of the Clark's staff. Students have the opportunity for internships and work-study at the Clark as well as at the Williams College Museum of Art and MASS MoCA, among others. Many graduates go on to obtain Ph.D.s from top universities, and the list of distinguished art institutions with Clark/Williams alumni on their staff comprise a who's who of American museums, including all major venues in New York and Washington, as well as museums in Philadelphia, Chicago, Los Angeles, Boston, Detroit, Atlanta, Baltimore, and numerous other cities.

Among the opportunities the graduate program offers is access to and training at the Williamstown Art Conservation Center (WACC), one of the nation's premier facilities for the restoration of works of art. WACC, though an independent entity, is located on the grounds of the Clark and has shared a close, reciprocal relationship with the museum. As the Institute has expanded its exhibition and research programs, the conservation center has been a significant resource for curators and scholars. The center was opened in 1977, one of several regional conservation labs built with grant money from the National Endowment for the Arts. Each year, in addition to

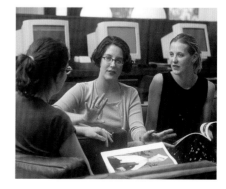

> "All activities of the corporation shall advance and assist the cause of art and learning for the general benefit and happiness of mankind."

offering a course in art conservation, WACC names one Lenett Fellow from the second-year graduate students to participate in the restoration of a work of American art or craft and present a public lecture on the process.

The graduate program was conceived in the 1960s and was the first initiative to expand the Clark's identity into realms of advanced scholarship. The program's roots go back to Sterling Clark, who wanted his collection used for study purposes, and so vested the Institute's 1950 charter with a clear vision. Among its other functions, the charter stated, the museum would provide "facilities for study and research in the fine arts." "All activities of the corporation," the document declared, "shall advance and assist the cause of art and learning for the general benefit and happiness of mankind."

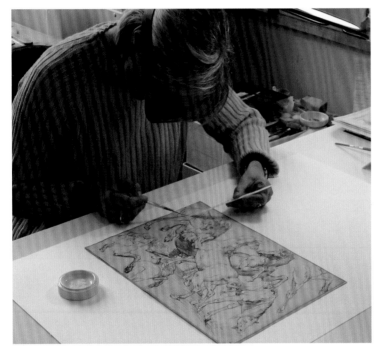

Clark could not have envisioned the scholarly heights his mandate would reach, particularly since his own training in visual arts was so self-directed. His skepticism toward art historians makes the pivotal role of scholars in the Clark's development all the more ironic. Even before the graduate program was established, the Clark Professorship at Williams (funded by the New York–based Robert Sterling Clark Foundation, which Sterling established in 1952) began to attract world-renowned art historians to Williamstown, not simply to lecture but to tour the Clark collection firsthand and advise the museum. George Heard Hamilton, the eminent expert on Impressionism, came to Williamstown first as a Clark Professor and was later hired to assist in the establishment of the graduate program. Hamilton, who helped found Yale University's department of art history, was persuaded in 1966 to leave New Haven to succeed Peter Guille, the Clark's first director. Hamilton oversaw a period of major growth before retiring in 1977. The library and gradu-

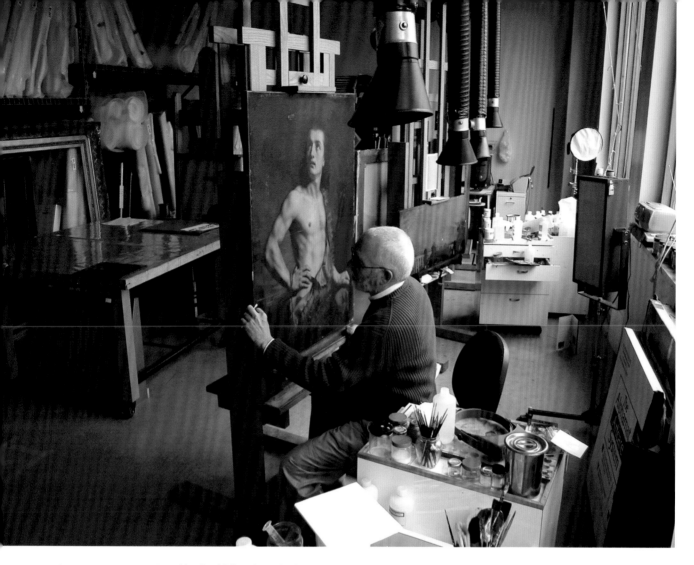

ate program were nurtured by David Brooke, who headed the Institute from 1977 until 1994, and research and academic acivities were expanded under the vision of current director Michael Conforti.

The Clark has always had a close connection to Williams College and Williamstown. Even before the Institute opened its doors, the first public exhibitions of the Clarks' collection were held at the Williams College Museum of Art, and from the beginning, the president of the college has held a seat on the Institute's board of trustees. The Clark has sponsored public conferences on aspects of Williams's art and rare books collections, and Clark Fellows benefit from access to the college's libraries and other resources. The two institutions are so intertwined in key aspects of their academic mission they are now nearly inseparable.

ABOVE, BELOW, AND OPPOSITE Staff at the Williamstown Art Conservation Center treat a variety of objects, including paintings, works on paper, sculpture, furniture—even the occasional mummy—for more than fifty museums throughout the eastern United States FOLLOWING PAGES Family and friends gather for free summer band concerts on the South Lawn; snowshoeing on Stone Hill

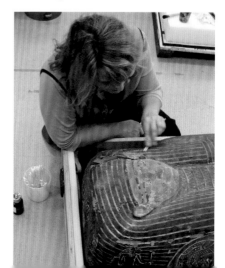

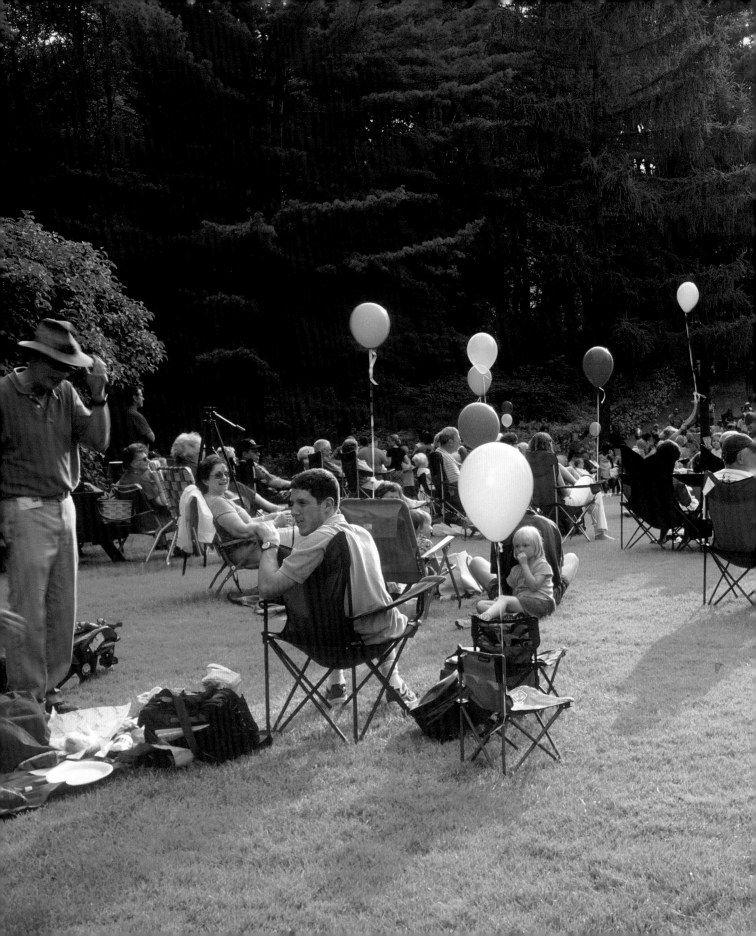

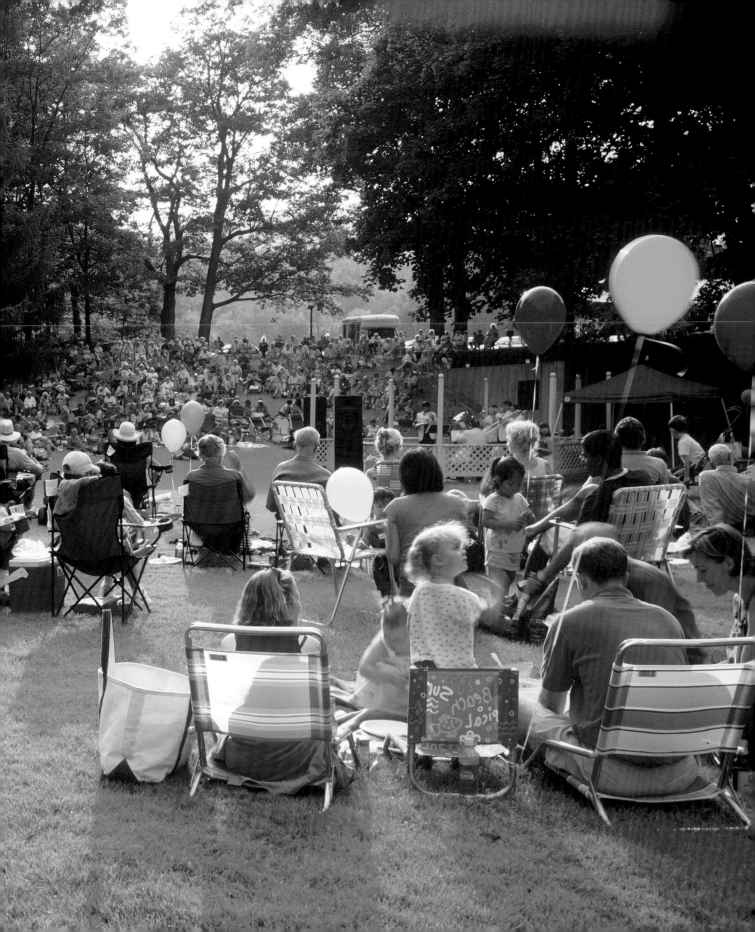

# The Library

Not long ago a visiting scholar tested the comprehensiveness of the Clark's art history library. The library, recognized as one of the best reference and research resources for art history and visual studies in the country, has long been a chief pride of the Institute.

Nevertheless, the scholar, skeptical perhaps of such claims from a library situated beside a cattle pasture, requested from the reference staff an extremely rare volume on a certain French painter. Yes, he was assured, we own that. Undaunted, the man asked for an even more obscure title on the same artist. Yes, said the reference librarian again, we have that too. And what about . . . the scholar pressed, and he named a book even more eso-teric and difficult to obtain. No problem, came the answer, and the librarian quickly extracted it from the shelf. The man tried hard not to look won over, but he eventually identified himself as the director of a prominent museum in Scotland, and told the librarian, "To get those three books back home, I'd have to get on a plane and fly to London."

In the early 1960s, as the Clark trustees committed resources to expand the Institute into a center of study and scholarship, their inital step was establishing a first-class art library. The collection began with Sterling Clark's own books on the subject and quickly expanded with more than 21,000 volumes from two prestigious private collections, those of the prominent

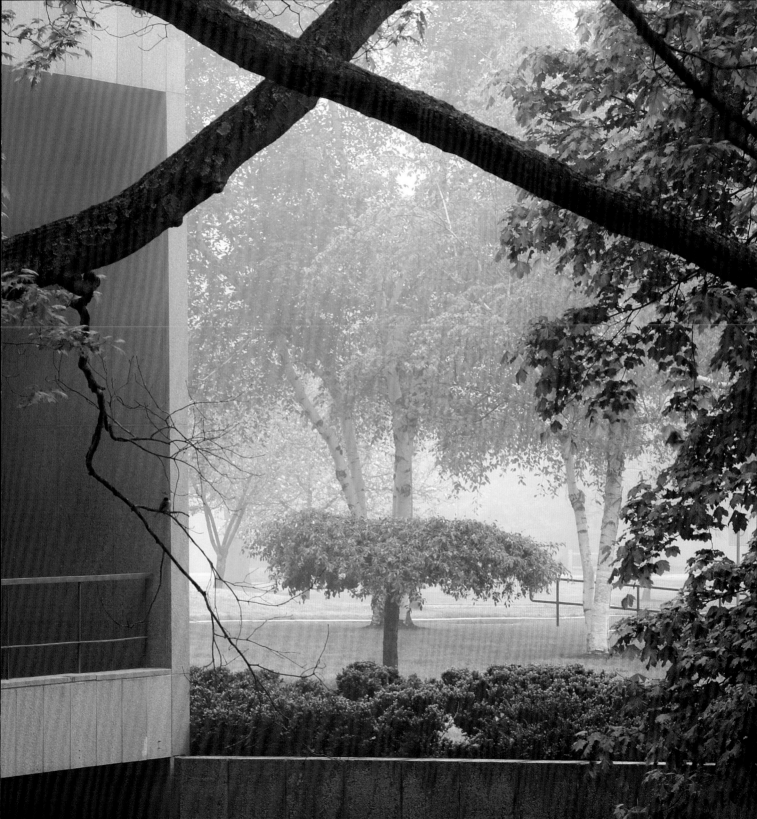

Ordo 3 Insecta Lepidoptera    Genus 1    Papiliones    Butterflies

Genus 3    Phalenæ    Moths.

Genus 2    Sphinges.

ABOVE Sunlight fills the Scott Opler Reading Room, where visitors can relax and browse current periodicals
TOP The library collection includes rare books, such as this 1781 volume from the Julius Held collection featuring detailed drawings of English insects

New York art dealers the Duveen Brothers and the late Dutch art historian W. R. Juynboll. Today, the catalog numbers some 200,000 titles, including histories, biographies, surveys, monographs, comparative studies, commentaries, treatises, and theoretical texts. Among the library's resources are subscriptions to 700 journals and an archive of some 35,000 auction sales catalogues.

The Clark library serves curators and other visiting experts, resident scholars, graduate students, and undergraduates from Williams College. Unique among major research libraries, nearly all of its resources are also available to the public in open stacks. In the summer, up to 75 percent of the reference questions are from the general public, many of which begin, "I have a painting . . . ." The library is noncirculating, but patrons are permitted to reserve books for extended use, and students and scholars are

provided carrels and small offices. Digital resources include an array of visual and text subscription databases.

The focus of the collection is European and American art from the early Renaissance to the present, representing every country, movement, and aesthetic stance. The section on French art, particularly of the nineteenth century, is especially comprehensive. The library adds some 5,000 new titles a year, and a portion of the acquisitions budget is explicitly dedicated to obtaining out-of-print books.

About 50 percent of the books are in English, with the remainder in the major European languages. Periodicals and reference volumes are also available in more than a half-dozen languages. The library is home to numerous special collections. The Mary Ann Beinecke Decorative Art Collection has books spanning a period from 1550 to the 1970s on costume design, handicrafts, and textiles. The Duveen Archive has albums, clippings, and correspondence of the Duveen Brothers firm. The Micah Lexier Collection features nearly a thousand titles associated with conceptual or minimalist art. Sterling Clark's own collection of some 1,600 volumes offers a number of exquisite illustrated books and literary first editions. Other collections include the David A. Hanson Collection of the History of Photomechanical Reproduction and an assemblage of about 1,500 artists' books. In addition, the library houses an archive of three-quarters of a million images of works of art from antiquity to the present.

Though many visitors to the museum overlook this extraordinary collection (it is "hidden in plain sight" off the main lobby), the research library regularly ranks among the Institute's most admired resources. The scholar mentioned above was not alone in being impressed. In written evaluations from academics in the Clark Fellows program, the library has been described as "terrific," "perfect," and "superlative." "Amazing depth," praised one art historian. "[T]here was far more for me to read than I could possibly get through." For a research library, there could be no higher praise.

ABOVE AND BELOW Unlike most major art history libraries, the Clark library has open stacks that can be browsed by researchers
FOLLOWING PAGES The Clark in winter, as viewed from atop Stone Hill

"To get these books back home, I'd have to get on a plane and fly to London."

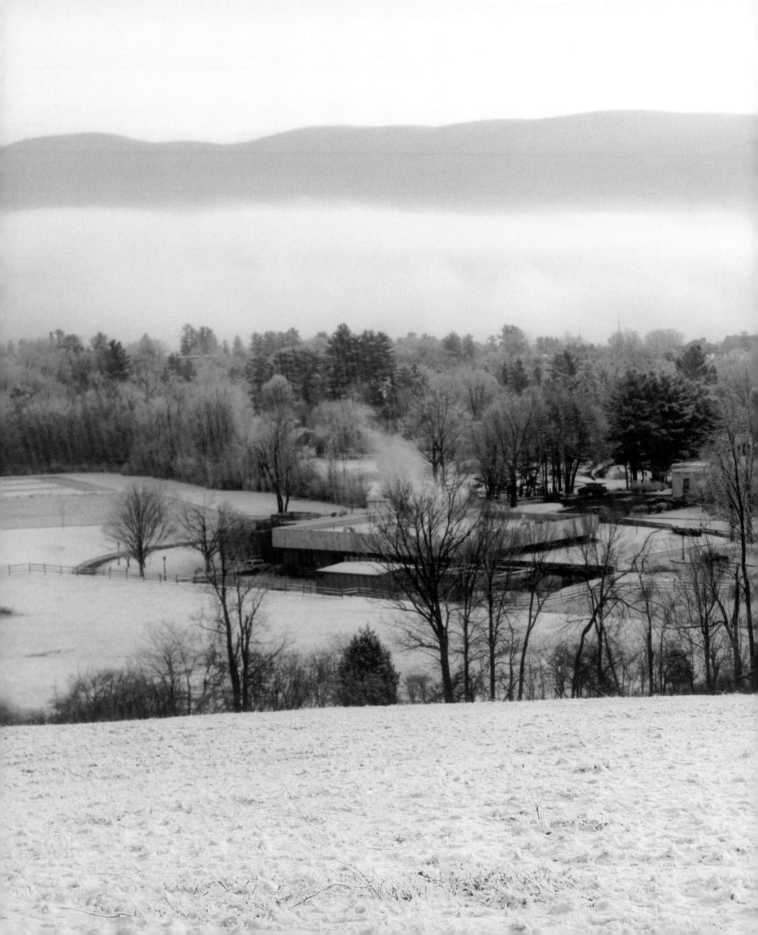

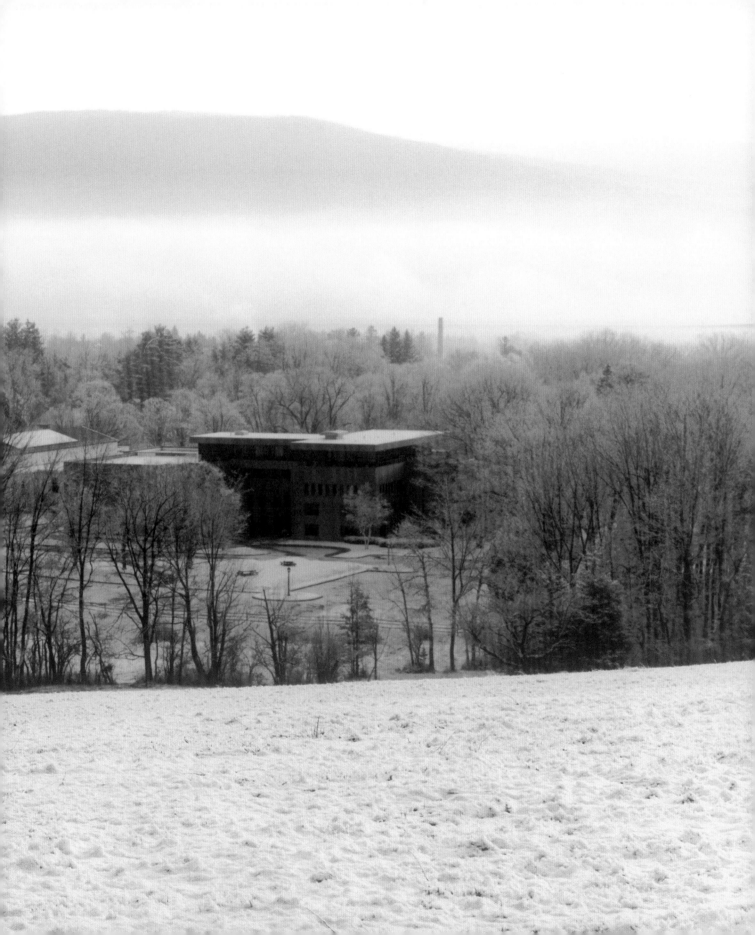

# A Museum of One's Own

While the popular image of museums sometimes portrays them as stuffy or impossibly esoteric caverns of refinement, the reality is that museum attendance regularly exceeds that of sporting events, rock concerts, and monster truck rallies. The public can't get enough art and is hungry to understand its principles and partake its pleasures.

At the Clark, the conversation about art is never limited to scholars and intellectuals. The Institute's broad range of education and public programs—lectures, gallery talks, symposia, as well as concerts, films, and family events—is infused by the same intellectual vigor and curiosity that underpin the research and academic programs. All offerings are designed to

OPPOSITE Free band concerts on the South Lawn attract hundreds of listeners who bring blankets, chairs, and picnics and then sit back and enjoy the music and scenery

BELOW The Clark's intimate galleries encourage visitors to enjoy great works of art at their own pace

ABOVE AND OPPOSITE Gallery talks at the Clark
uncover the fun and mystery of looking at art
RIGHT Children gather in the sun at one of
the Clark's family days

"the advantage of seeing
good pictures . . . would have a
distinct influence on their future."

encourage children and adults, first-timers and old hands, to look carefully,
think independently, and create their own moments of discovery.

Sterling Clark understood that his museum would benefit students,
observing that "the advantage of seeing good pictures . . . would have a dis-
tinct influence on their future." This belief is made manifest
at the Clark, where during the school year busloads of chil-
dren from preschool through high school gather noisily in the
lobby and are led in groups to look at the paintings. The Clark
reimburses transportation expenses for any school group that can make the
journey to the Clark and back home in one day.

On these talks, it is not uncommon to see school kids talking about
perspective in a Renaissance panel, or religious symbolism in a seventeenth-

century landscape. On one recent tour, a clutch of fifth-graders was led to the fourteenth-century Ugolino altarpiece, the museum's oldest artwork, with its depiction of Mary and Jesus flanked on each side by a trio of saints. To demonstrate how the artist symbolized the divinity of the mother and child, the group leader had the students slowly crouch down, until they were nearly kneeling. From that lowered position, looking up at the painting as church-goers would have gazed at the high altar some seven hundred years ago, light glanced off the gold-leaf halos of the central figures and flashed like sunshine on water. In unison the group uttered a kind of semi-hushed, "Wow!" and every set of eyes flashed in excitement. Needless to say, the class was all in for the lesson on Renaissance art that followed.

       Adults are offered the same ah-hah moments. Gallery talks add cultural, historical, and technical context to the artworks, deconstructing the iconography in Quentin Massys's *Virgin and Child with Saints Elizabeth and John the Baptist*, or the color theory behind Monet's *Rouen Cathedral, The*

ABOVE *Rouen Cathedral, The Façade in Sunlight,* 1894, by Claude Monet (Purchased in memory of Anne Strang Baxter)

BELOW The impressive fourteenth-century altarpiece by Ugolino di Nerio, the first piece acquired after the opening of the Institute, is the earliest work in the collection

ABOVE The Clark's performing arts programs include concerts ranging from folk and blues to classical and world music
BELOW LEFT For family days, the campus is transformed into another place and time, such as a Victorian seaside for one recent event
OPPOSITE AND BELOW RIGHT The Clark's fiftieth anniversary celebration featured fifty continuous hours of activities, including an evening of ghost stories and fireworks on Stone Hill

*Facade in Sunlight*. Likewise, in-depth lectures offered on individual pieces offer collateral illumination on other works in the collection. A consideration of François Boucher's 1760 *Laundresses in a Landscape*, for instance, might reveal not only the subtext of the wanton playfellow spying at the young house-servants and the artist's importance as a Rococo court painter but also that Boucher was painting master to Fragonard, who was the great-grandfather of Berthe Morisot, who studied with Corot and modeled for Manet (and married his brother). Paintings have family trees as interesting as those of some people.

The Clark's outreach also encompasses entertainment programs, though in every case the aim is to connect visitors to the museum experience. Sometimes this takes the form of simply inviting people onto the premises. Family Day, a free carnival of art activities, games, and gallery talks held on the grounds, attracts thousands of children and adults from Williamstown, and across Berkshire County, southern Vermont, and eastern New York. Festivities at the Institute have ranged from transforming the front lawn into an English seaside featuring a sandy beach to maple sugar-making

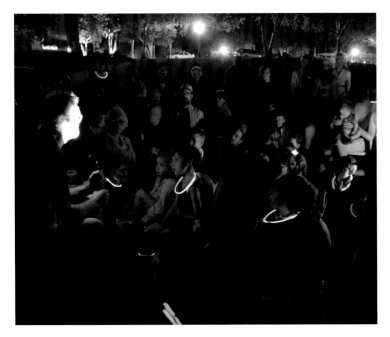

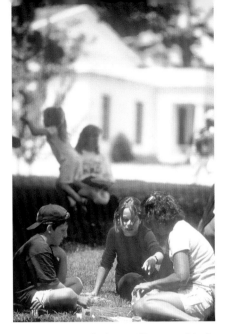

ABOVE Family days provide opportunities for children and adults to enjoy art and activities together on the Clark's beautiful grounds

ABOVE The Clark's domestically scaled galleries include large windows that provide sweeping views of the stunning Berkshire landscape

RIGHT AND PREVIOUS PAGES Summer band concerts on the South Lawn are a perennial favorite with the local community

demonstrations to "Clark After Dark," an evening that revealed "ghosts" in several paintings. One way the institution shows gratitude to the community is through a series of free summer concerts on the South Lawn. Locals arrive with lawn chairs, picnic baskets, and the kids and fill the lawn's natural amphitheater to hear folk music, military marches, or bluegrass. It's a scene Renoir could have painted—the sun slipping behind tall oaks, the crowd's bright summer outfits, musicians on the bandstand, children tumbling and playing ball, and groups of neighbors smiling and enjoying each other's company.

Residents and regular visitors to the museum often develop a distinct pride of ownership in the Clark. The Institute's presence in the Berkshire community is large; it was one of the first cultural institutions to put the region "on the map" and is a destination point for cultural tourists across the globe. Even without the international reputation, anyone with regular access

to the Clark soon develops a fondness for the place. During the off-season, admission to the galleries is free, and use of the grounds is always unrestricted. The Clark's 140-acre campus is one of the northern Berkshires' nicest recreational resources. In spring, summer, and fall, miles of trails allow a brisk hike or leisurely stroll, and in the winter, offer excellent cross-country skiing.

And it only takes one good Berkshire snowstorm to transform Stone Hill into a terrific sledding course.

One of the finest views of the Clark landscape can be found inside the museum, through the large brass windows that grace its Old Masters galleries. The scene, looking north, offers a perfect pastoral. A gray split-rail fence fronts a rustic pond, amid fields and the hills beyond. In the summer, the pond blooms with water lilies. In October, it shimmers with the pageant of autumn leaves. The scene is lovely every season of the year. One afternoon, in the middle of a snow squall, I saw three deer emerge to drink at the pond's edge. It was like living for a moment in a Chinese scroll painting.

Sterling Clark insisted on these windows to bring the outdoors into his museum, and he was right. The phrase "art in nature" was born at the time the Japanese architect Tadao Ando unveiled his design for the planned expansion of the Institute's facilities. The idea also defines the Clark itself.

The Berkshires are a magnificent frame for the Clark. To hike the wooded trails behind the museum is to comprehend the collection ever more profoundly. The walk cuts through tall maples and bright ferns, past fallen birches like the bones of some great mythic beast. Quiet descends, and with

ABOVE One young visitor learns about maple sugar-making at a family day
BELOW A solitary skier cuts through fresh snow atop Stone Hill

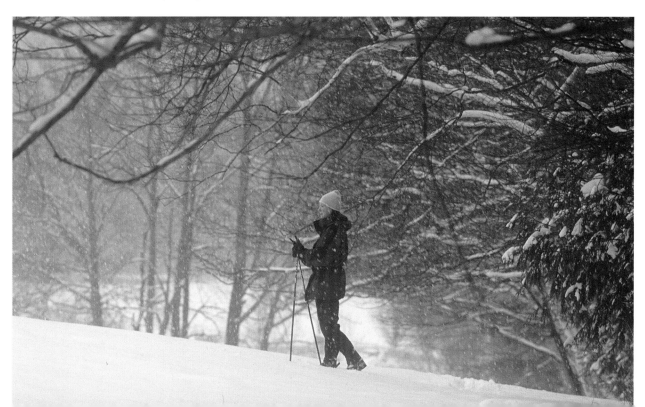

it an awareness of those nineteenth-century romantic painters who found in nature a succession of emotions—pleasure, awe, reverie, tranquility, grace.

The trail eventually climbs to the place of an old stone bench, then starts gently down along a broad, grassy avenue. A gnarled tree brings to mind the old Dutch landscapist Ruisdael. The path cuts through a high pasture of wild roses and pale yellow butterflies, and into a swale. Trees punctuate the rising meadow like something out of Constable or Corot—it's real, and something more than real. The panorama inspires the viewer to reflect on the lesson that centuries of great art have sought to teach us. In the realms of science and spirit, nature does not ask us to take sides.

Standing at the crest of Stone Hill, the Institute and the landscape become one. The marble temple and granite citadel stand proudly amid the natural beauty that surrounds them. When Ando visited here from Japan, he imagined a broad reflecting pool and an expansive glass building for the Clark, architecture not simply framed by nature, but absorbed by it.

As the Sterling and Francine Clark Art Institute moves into its future, echoes of the past reverberate. At the laying of the museum cornerstone in August 1953, a ceremonial trowel was presented to Sterling and Francine Clark, with a prophetic inscription:

> We are these days much preoccupied with wars and rumors of wars, with atomic and hydrogen bombs. These fill our newspaper headlines and plague our hearts and minds. But it may be that in the wisdom of God this too shall pass away, and the future shall belong to some simple and quiet event which no one can now see. The laying of this cornerstone will make no headlines. Yet within these walls is to be housed beauty which has already stood the test of time and which will far outlast the tumult of today. In this place men and women will be strengthened and ennobled by their contact with the beauty of the ages.

For the Clark at half-century, this legacy continues to endure and increase.

ABOVE AND OPPOSITE Jacob van Ruisdael's *Landscape with Bridge, Cattle, and Figures,* painted in Holland more than three hundred years ago, resonates with the pastoral beauty of the Clark's setting; when seen from the crest of Stone Hill, the Clark literally becomes "art in nature"

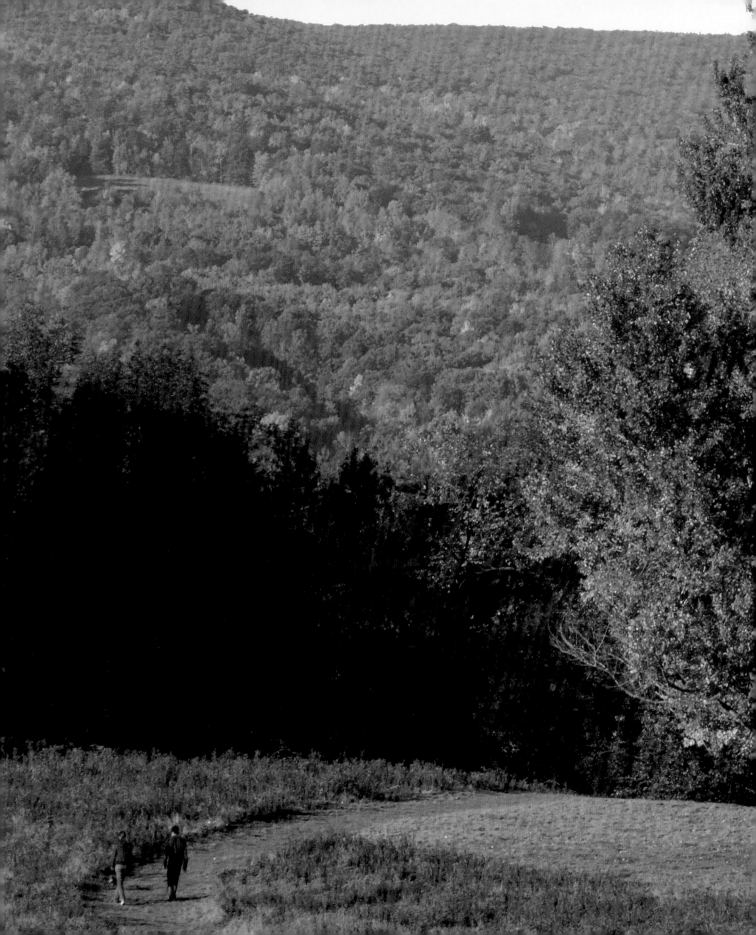

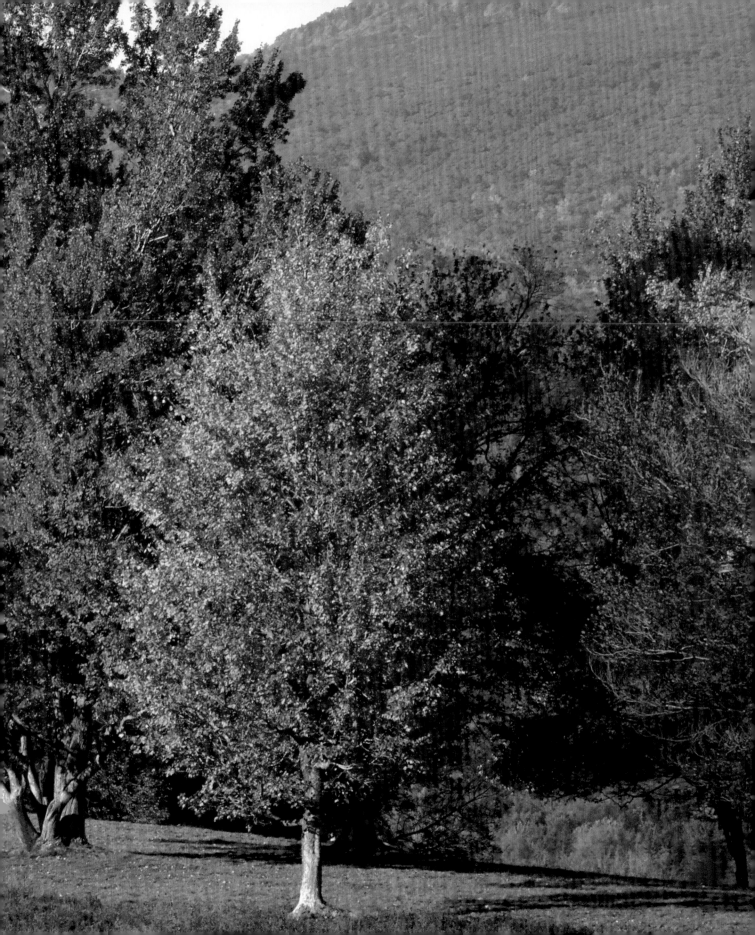